THROUGH DARKNESS TO LIGHT

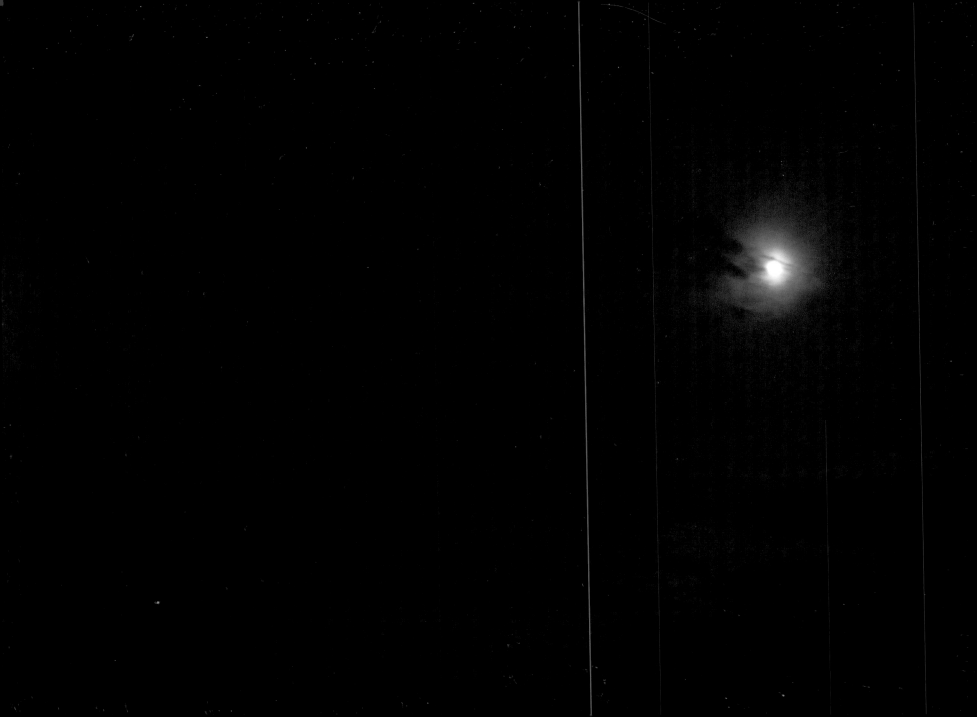

Through Darkness to Light

————

PHOTOGRAPHS ALONG THE UNDERGROUND RAILROAD

a photographic essay by

Jeanine Michna-Bales

FOREWORD BY Andrew J. Young

ESSAYS BY Fergus M. Bordewich, Robert F. Darden, AND Eric R. Jackson

PRINCETON ARCHITECTURAL PRESS · NEW YORK

previous: *Traveling by Moonlight*, 2014
page 10: *Through Darkness*, 2014

Published by
Princeton Architectural Press
A McEvoy Group company
37 East Seventh Street
New York, New York 10003
202 Warren Street,
Hudson, New York 12534
Visit our website at www.papress.com

33614080202418

Printed and bound in China by 1010 Printing International
20 19 18 17 4 3 2 1 First edition

Editor: Jenny Florence
Design: Paul Wagner, Mia Johnson

Special thanks to: Janet Behning, Nicola Brower, Abby Bussel,
Erin Cain, Tom Cho, Barbara Darko, Benjamin English, Jan Cigliano Hartman,
Lia Hunt, Valerie Kamen, Simone Kaplan-Senchak, Stephanie Leke,
Diane Levinson, Jennifer Lippert, Kristy Maier, Sara McKay,
Jaime Nelson Noven, Esme Savage, Rob Shaeffer, Sara Stemen,
Joseph Weston, and Janet Wong of Princeton Architectural Press
—Kevin C. Lippert, publisher

Library of Congress
Cataloging-in-Publication Data

Michna-Bales, Jeanine
Through darkness to light : photographs along the underground railroad /
a photographic essay by Jeanine Michna-Bales
ISBN 978-1-61689-565-5 (alk. paper)
1. Underground Railroad—Pictorial works. 2. Underground Railroad .
3. Fugitive slaves—Travel—United States—History—Pictorial works
4. African Americans—History—19th century—Pictorial works.
5. Historic sites—United States—Pictorial works.
LCC E450 .M58 2017 | DDC 973.7/11500222—dc2

Contents

Foreword – 7
ANDREW J. YOUNG

Introduction – 11
JEANINE MICHNA-BALES

————

**PART I
THE UNDERGROUND RAILROAD**
15

**Bound for Freedom:
The History of the Underground Railroad** – 17
FERGUS M. BORDEWICH

**Let Freedom Ring:
The Underground Railroad Comes Alive** – 29
ERIC R. JACKSON

The Spirituals – 33
ROBERT F. DARDEN

**PART II
THE JOURNEY:
A PHOTOGRAPHIC ESSAY**
37

————

Notes on the Photographs – 184
Epigraph Sources – 185
Bibliography – 186
Contributors – 189
Acknowledgments – 190

Foreword

ANDREW J. YOUNG

T hroughout my life and work I have been inspired by the stories and the legacy of the Underground Railroad. I remember, in particular, a phrase attributed to Harriet Tubman that I very much admire. When told of all the slaves she brought to freedom, she is said to have remarked, "I could have freed a thousand more if only they knew they were slaves." I think of her words today when I see how many people fail to understand the extent to which they may still be enslaved. Not in the sense of the chain and the whip, but in the sense of the modern mechanisms that manipulate us into being consumers rather than people. In fact, Martin Luther King Jr. used to say, "Going from a brown bag to a martini glass is not freedom." In his mind, that was one of the dangers of the black bourgeois—unwittingly becoming slaves of materialism.

The Underground Railroad has been described as the first civil rights movement in the United States because it blurred racial, gender, religious, and socioeconomic lines and united people in the common cause of ending the injustice of slavery. I agree, and would offer the *Amistad* Rebellion and the group of slaves that mutinied off the coast of Long Island as an example of a similar, and connected, campaign. They were jailed in New Haven and most spoke the same language, so they had the benefit of communication and developed a leadership structure. These leaders, with the help of alumni of Yale University,

persuaded former president John Quincy Adams to come out of retirement and successfully argue their case for freedom. More than half of them returned to Freetown, Sierra Leone, while a few remained, including a young woman, Sarah Margru Kinson, who would attend Oberlin College. In my opinion this was the start of the anti-slavery movement in the United States, and it was initiated by white people who recognized in black people a humanity that before they had not been willing to see or that they had not had the chance to see. In this same manner, the Underground Railroad serves as a constant reminder that those in bondage had help, and that we should always strive to help others in need.

The spirituals and songs of the Underground Railroad also had an impact that can still be heard today. These songs were an essential part of the modern civil rights movement. I remember how we sang,

Freedom
Oh Freedom over me
And before I'd be a slave,
I'd be buried in my grave.
Woke up this morning
with my mind stayed on Freedom

Now, normally that was, "Woke up this morning, with my mind stayed on Jesus." We changed it to "Freedom." And Martin Luther King Jr. used to quote, "Jeremiah, is there no balm in Gilead? Is there no physician there?" He would say that black men and women in slavery took Jeremiah's question mark and straightened it out into an exclamation point. And they sang,

There is a balm in Gilead
that makes the wounded whole.
There is a balm in Gilead
that heals the sin-sick soul

So, when I get discouraged
and think my work's in vain
Then comes the Holy Spirit
to revive my soul again
Because there is a balm in Gilead
that makes the wounded whole.

The theme of faith in the midst of darkness appeared in the spirituals of the 1800s and in the music of the 1960s, during the civil rights movement, such as this song by Curtis Mayfield:

It's all right, have a good time
'Cause it's all right, whoa, it's all right

and in 1980s Jamaica when Bob Marley sang,

One love
One heart
Let's get together and feel alright

and most recently when Kendrick Lamar rapped a piece that ends with everybody jumping up and shouting

But, if God got us then gon' be alright

One thing is certain: the answer has been in front of us for years. Like the Underground Railroad, if we all work together

I gotta feeling everything's gonna be all right.

Introduction

JEANINE MICHNA-BALES

G rowing up in the Midwest, the Underground Railroad was understandably an important part of our school curriculum given that some of the routes ran literally through our backyards. I became fascinated with the topic, and often imagined what it must have been like to walk thousands of miles for the chance to be free.

Years ago, I started to write—with a pen on paper—three pages a day. Most of the time I write whatever random thoughts come to me or just list things that have to be done before I can board a plane the next day. Sometimes, though, I'm rewarded for my effort and an exciting idea appears on the page. Such was the case about fifteen years ago when I started to get back into photography. I began to imagine what the journey north to freedom on the Underground Railroad would have looked like through the eyes of one individual.

I began doing research, and after many starts and frustrating dead ends, my stepfather suggested that we stop by the Indiana Historical Society library. I stumbled on a gold mine that day. A librarian shared a clipping file containing newspaper articles, photocopies of research papers, and other documents (many with notes in the margins referencing other sources) that mentioned the Underground Railroad. With this wealth of information, I was finally able to find individuals, cities, and routes along the part of the Underground Railroad that ran through Indiana.

In the early fall of 2012, while in Tennessee visiting my husband's family, I took the first few photographs. I had some prints made after returning home and one image stood out. It was a forest at night that evoked such a sense of mystery and foreboding that I knew this was exactly how I wanted to shoot the entire series.

I continued researching through the winter and headed back to Indiana in the spring. My entire family ended up getting involved. We would scout for locations by day—many were very vaguely suggested—and return at night to photograph. I will always remember the Friday the thirteenth my mother and I spent in a cemetery, and the time my sister and I raced the sunrise south through the state of Michigan trying to capture as many images as I could before dawn. Even my brother-in-law joined in, spending a night traipsing along the Natchez Trace in Tennessee. And when family was too distant, I hired off-duty police officers to accompany me.

Shooting at night, listening to all the natural sounds, I was overwhelmed with a sense of how vast, strange, and forbidding these remote places must have felt to those making the journey to freedom: the cicadas, the wind rustling through the trees, water trickling in a stream, coyotes howling in the distance, bullfrogs singing. In many places you could feel the history that surrounded you. This was particularly true at the Magnolia Plantation in Louisiana. Standing in the near pitch-black of a field, looking at the remains of the old slave quarters, put the project into perspective.

I began to understand along the way that there were so many different people who made up the Underground Railroad: from the freedom seekers themselves to other slaves, free blacks, abolitionists, Quakers, Presbyterians, the wealthy, the poor, female, male. Everyone worked together to strike a blow against the evils of slavery.

These disparate groups and individuals united in a common cause and eventually began to turn the tide. Of course, things didn't change overnight; it took years of political struggle and a bloody Civil War to bring slavery to an end. Even then, the fight for equality was—and many would say still is—far from over.

My hope is that this project will help illuminate the darkened corners of our shared history and show us that when we work together great things can be accomplished.

As Frederick Douglass might have wished, may we all come through the darkness into the light.

Slavery is one of those monsters of darkness to whom the light of truth is death. Expose slavery, and it dies. Light is to slavery what the heat of the sun is to the root of a tree; it must die under it. All the slaveholder asks of me is silence. He does not ask me to go abroad and preach in favor of *slavery; he does not ask any one to do that. He would not say that slavery is a good thing, but the best under the circumstances. The slaveholders want total darkness on the subject. They want the hatchway shut down, that the monster may crawl in his den of darkness, crushing human hopes and happiness, destroying the bondman at will, and having no one to reprove or rebuke him. Slavery shrinks from the light; it hateth the light, neither cometh to the light, lest its deeds should be reproved. To tear off the mask from this abominable system, to expose it to the light of heaven, aye, to the heat of the sun, that it may burn and wither it out of existence, is my object in coming to this country. I want the slaveholder surrounded, as by a wall of anti-slavery fire, so that he may see the condemnation of himself and his system glaring down in letters of light.*

—Frederick Douglass, from a speech at Finsbury Chapel, Moorfields, England, May 12, 1846[1]

1. Frederick Douglass and David W. Blight, *My Bondage and My Freedom* (New Haven, CT: Yale University Press, 2014), 341–342.

PART I

THE UNDERGROUND RAILROAD

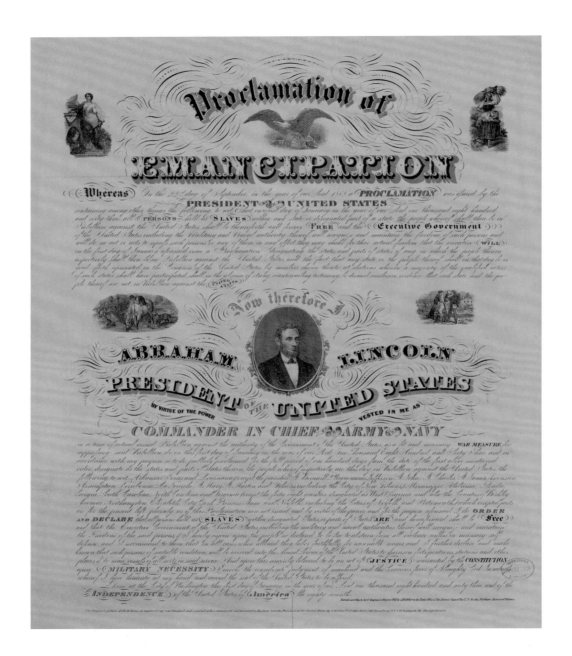

Emancipation Proclamation broadside, 1864. The Alfred Whital Stern Collection of Lincolniana, Rare Book and Special Collections Division, Library of Congress, Washington, DC.

Bound for Freedom:
The History of the Underground Railroad

FERGUS M. BORDEWICH

In April 1870, Underground Railroad veteran Levi Coffin told a huge interracial rally gathered in Cincinnati to celebrate the passage of the Fifteenth Amendment, which extended suffrage to African Americans, "Our underground work is done." The seventy-three-year-old Coffin, a Quaker who had been a pillar of the Underground Railroad since 1820 and had assisted more than a thousand fugitive slaves to freedom, declared, "As we have no more use for the road, I would suggest that the rails be taken up and disposed of, and the proceeds appropriated for the education of the freed slaves."[1]

The practical work of the Underground Railroad effectively ended during the Civil War, as Union armies liberated slaves across the South by the hundreds of thousands. Now the new amendment—along with the Thirteenth and Fourteenth Amendments, which ended slavery and declared former slaves citizens, respectively—promised both to protect African Americans' civil rights and to foster their integration into American life. That, of course, was not to be, as the racist ideology of Jim Crow tightened its grip and blacks were once again reduced to near servitude, their aspirations held in check by discriminatory laws, night-riding Klansmen, and the lynch rope.

In time, the Underground Railroad slipped into the realm of myth, characterized by legends of secret tunnels, exotic hiding places, and even alleged quilt maps, a twentieth-century notion that turned one of the most remarkable movements in the nation's history into little more than a quaint folktale. The reality of the Underground Railroad is far more significant than its fictions. It was a movement with far-reaching political and moral consequences that did much to change antebellum America. It was the nation's

first interracial movement, involving free blacks, antislavery whites, and slaves; the nation's first great movement of civil disobedience since the American Revolution, engaging thousands of citizens in the subversion of hated federal and state laws; the first American mass movement that asserted the principle of personal, active responsibility for others' human rights; and a significant political movement that was fueled largely by religion. It was also one of the seedbeds of American feminism, as both black and white women were participants on an equal plane with men, sheltering and clothing fugitive slaves, acting as guides, and insisting that their voices be heard. As the nineteenth-century feminist Elizabeth Cady Stanton—who was radicalized while sharing a dinner table with fugitive slaves at her cousin Gerrit Smith's upstate New York home—put it, "Woman is more fully identified with the slave than man can possibly be."[2]

From the earliest days of slavery, swamps, forests, and sometimes Native American communities served as refuges for freedom seekers. But the first organized network to systematically protect and conceal fugitives with the deliberate intention of liberating them appeared in Philadelphia at the end of the eighteenth century. There, to a far greater degree than in any other place in the country, African Americans were free to create their own community as they desired it to be, giving birth to the nation's first black churches, schools, and mutual aid societies, its first black middle class, and eventually its first black political activists. Philadelphia was also the headquarters of the Quaker-led Pennsylvania Abolition Society, which called upon all Christians "to use such means as are in their power to extend the blessings of freedom to every part of the human race," in particular those

"who are detained in bondage by fraud or violence."[3] The synergy between these two groups—free blacks and antislavery Quakers—ignited the radical underground, which by the 1790s and early 1800s was pioneering strategies that would gradually spread wherever the underground operated, such as the use of multiple safe houses, disguises, long-distance transportation of fugitives, and litigation against slave hunters.

The underground's godfather was Isaac Tatum Hopper, who was appointed the Quaker community's liaison to local free blacks, and threw himself into actively fostering fugitives' escape in collaboration with African American allies. So successful was he that it was said that thwarted slave hunters "had abundant reason to dread Isaac T. Hopper as they would a blister of Spanish flies."[4] Hopper later moved to New York City, where he helped develop the Underground Railroad with Connecticut-born David Ruggles, a radical black activist and journalist, who in turn assisted the northward flight of Frederick Douglass to Massachusetts in 1838.

In time, the Underground Railroad spanned the free states from Maine to Iowa, and extended into Canada. (Contrary to popular lore, most fugitives did not settle in Canada; they stayed in the United States where they felt safe and found work.) Although some fugitives managed against all odds to escape from the Deep South, the organized system of the underground rarely reached more deeply than about one hundred miles into the slave states. Most successful freedom seekers, in fact, came from just three states: Maryland, Virginia, and Kentucky, all of which had long borders with free states, and where routes north were well known. A "Saltwater Underground" also operated from ports

Advertisements offering rewards for the recapture of runaway slaves in the *New Orleans Bee*, November 16, 1833. Louisiana Division/City Archives, New Orleans Public Library.

Cover of the *American Anti-Slavery Almanac*, 1844. Indiana Historical Society.

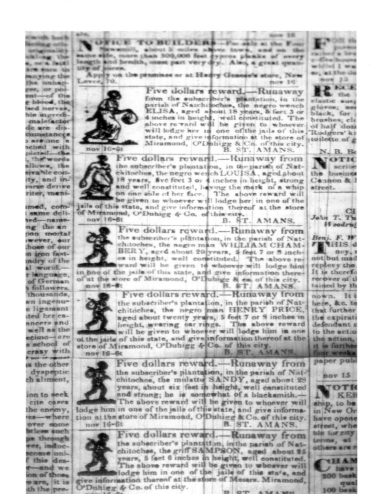

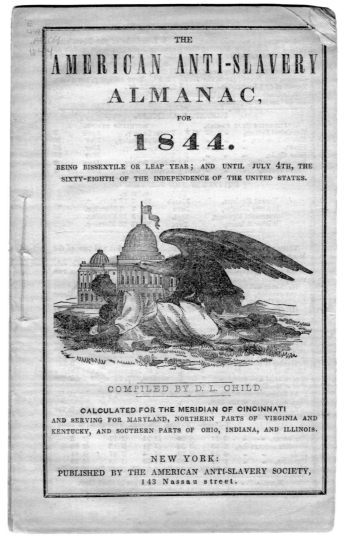

on the East Coast—most notably in Norfolk, Virginia—and New Orleans, spiriting freedom seekers to the North and to British possessions in the Caribbean, where slavery had been outlawed.

The underground rapidly expanded beginning in the 1830s with the proliferation of antislavery societies across the northern states. Such aboveground groups were essentially farm teams for the more radical activists of the underground, as well as their human infrastructure of support. Along with "stationmasters," who ran safe houses, and guides, or "conductors," the underground included itinerant preachers, teamsters, peddlers who carried messages in their packs, slaves who themselves never fled but provided information regarding escape routes to those who did, sailors and ships' stewards who concealed runaways on their vessels, lawyers who were willing to defend fugitives and those who were accused of harboring them, and businessmen who provided needed funds, as well as an even wider pool of family members, friends, and fellow parishioners who, though they might never engage personally in illegal activity, protected those who did and made it possible for them to continue their work. Although Quakers and African Americans were always prominent in the Underground Railroad, it included many white Northerners of various other Christian denominations.

By the 1840s, the Underground Railroad was a diverse, flexible, interlocking system that operated with astonishing efficiency but without central control. There was never any "president" or "general manager" of the Underground Railroad, or even any overall national organization; in practice, it was a model of democracy in action. As Isaac Beck, a stationmaster in Ohio, put it, "There was no regular organization, no constitution, no officers, no laws or agreement or rule except the 'Golden Rule,' and every man did what seemed right in his own eyes."[5] The majority of white activists were driven by a spiritual imperative that proclaimed slavery to be a sin that could only be eradicated by personal action. In the words of Levi Coffin, "If by doing my duty and endeavoring to fulfill the injunctions of the Bible, I injured my business, then let my business go. As to my safety, my life was in the hands of my Divine Master, and I felt that I had his approval."[6] Black activists, many of them former slaves themselves, were most often motivated by a desire to free family members or friends, or by bitter memories of their own degradation. Reverend Jermain Loguen, who escaped from servitude in Tennessee, wrote to his fellow underground collaborator in upstate New York, Frederick Douglass, "Had I not been terribly wronged, as you and all our race, I think I should have been a very still, quiet man. Oppression has made me mad; it has waked up all my intellectual and physical energies."[7]

The underground's expansion coincided with the spread of iron railroads. While earlier activists typically spoke of their collaborators simply as a "line of posts" or a "chain of friends," the language of railroading lent itself perfectly to what the underground had already been doing for decades, now referring to safe houses as "stations," fugitives as "passengers," the farm wagons in which they traveled as "cars," and the operation generally as the delivery of shipments of "black ink," "indigo," or "finest coal" by "train."

Although Underground Railroad operatives used such cryptic language when necessary, the system was never

STOCKHOLDERS
OF THE UNDERGROUND
R. R. COMPANY
Hold on to Your Stock!!

The market has an upward tendency. By the express train which arrived this morning at 3 o'clock, fifteen thousand dollars worth of human merchandise, consisting of twenty-nine able-bodied men and women, fresh and sound, from the Carolina and Kentucky plantations, have arrived safe at the depot on the other side, where all our sympathising colonization friends may have an opportunity of expressing their sympathy by bringing forward donations of ploughs, &c., farming utensils, pick axes and hoes, and not old clothes; as these emigrants all can till the soil. N. B.—Stockholders don't forget, the meeting to-day at 2 o'clock at the ferry on the Canada side. All persons desiring to take stock in this prosperous company, be sure to be on hand.
Detroit, *April* 19, 1853.
By Order of the
BOARD OF DIRECTORS.

Reproduction of a broadside calling for donations for formerly enslaved African Americans newly arrived on the Underground Railroad, April 19, 1853. Burton Historical Collection, Detroit Public Library.

entirely as secret as legend claims. In the slaveholding states and in border areas, activists concealed their work as best they could. But farther north, it was surprisingly open, so much so that Frederick Douglass, who served as a station-master in Rochester, wryly referred to it as the "upper-ground railway."[8] Harriet Tubman took at least some of her fugitive companions to Grand Central Station in New York, and bought them ordinary train tickets to travel to Albany.

When forty-five fugitives marched through Battle Creek, Michigan, one day in 1847, an eyewitness later recalled, "Everybody heard of their coming, and every man, woman, and child in town was out to see them."[9] In Syracuse, New York, Jermain Loguen advertised his home in newspapers as the main Underground Railroad station, while public fundraisers for the local underground were held in that city's council chambers. Abolitionist newspapers such as the

Advertisement for Levi Coffin's store promising "free labor dry goods and groceries" in the *Free Labor Advocate, and Anti-Slavery Chronicle*, July 1, 1847. Friends Collection, Lilly Library, Earlham College.

Advertisement outlining the aims of the *North Star*, an anti-slavery weekly proposed by Frederick Douglass, in the *Free Labor Advocate, and Anti-Slavery Chronicle*, September 30, 1847. Friends Collection, Lilly Library, Earlham College.

THIS WAY B'HOYS.

THE undersigned takes this method of informing those interested that his Accounts and notes are placed in the hands of Jonathan Unthank Esq., for collection, those wishing to close their accounts by Note or Cash, will place CALL SOON. A word to the wise &c. J. S. COTTOM.
Newport Indiana, June 10th 1847.

FREE PRODUCE STORE.

THE Undersigned is now opening a store for the sale of FREE LABOR DRY GOODS, AND GROCERIES, and invites the attention of Retail Merchants, and all who may wish to purchase such goods.

No Slave Labor products will be knowingly kept in his Store.

The Cotton goods have been manufactured by the "American Free Produce Association," and by the "Free Produce Association of Friends, of Philadelphia Yearly Meeting," of Cotton raised and ginned by Free Labor.

He will be continually receiving, and has now on hand, the following articles, which will be sold at a moderate advance on cost, for cash.

Shirting and Sheeting; Muslin, bleached & brown; Manchester and domestic Ginghams—various stiles and qualities; Colored Cambrics and Canton Flannel —assorted colors; Table Diapers; Colored Table cloths—imitation of Linen; Gingham handkerchiefs; Long and half Hose; Bed Ticking; Brown Drilling; Apron ann Furniture Checks; Twilled Pantaloon Stuffs; Cotton Yarn; Carpet Warp; Cotton Laps and Wadding; Candle-wick; Wrapping Twine.

ALSO,

Refined Loaf Sugar; Laguayra brown Sugar; Maple Sugar a superior article; British West India Molasses. Laguyra, St. Domingo and Java Coffee; Teas; Madras, Manila and Bengal Indigo; Pepper, Alspice, Alum, Coperas, Ginger, Madder, Salt, Fish, Nails, &c., &c., &c.,
LEVI COFFIN, Ag't
AND COMMISSION MERCHANT.
N. W. Corner of Ninth and Walnut Streets, CINCINNATI.
6th mo. 10th, 1847. 33—tf.

HAT MANUFACTORY.

JOHN S. HUNT takes this method of returning his thanks to his former friends and customers

PROSPECTUS

FOR AN ANTI-SLAVERY PAPER.

NORTH STAR.

FREDERICK DOUGLASS proposes to publish in Cleveland Ohio, a WEEKLY ANTI-SLAVERY PAPER, with the above title.

The OBJECT of the NORTH STAR will be to attack Slavery in all its forms and aspects—advocate UNIVERSAL EMANCIPATION—exalt the standard of Public Morality—promote the Moral and Intellectual Improvement of the COLORED PEOPLE—and hasten the day of FREEDOM to the Three Millions of our Enslaved Fellow countrymen.

The paper will be printed upon a double medium sheet, at $2,00 per annum, if paid in advance, or $2,50 if payment be delayed over six months.

The names of subscribers may be sent to the following named persons, and should be forwarded as soon as practicable.

FREDERICK DOUGLASS, Lynn, Mass.
SAMUEL BROOKE, Salem Ohio.
M. M. DELANY, Pittsburgh, Pa.
VALENTINE NICHOLSON, Harveysburgh, Warren county, Ohio.
JOEL P. DAVIS, Economy, wayne co. Ind.
CHRISTIAN DONALDSON, Cincinnati Ohio.
J M. MCKIM, Philadelpha, Pa.
AMARANCY PAINE, Providence, R. I,

Newspapers wishing to exchange with the North Star, will please give a few insertions to the above, and forward a paper containing it to the North Star, Cleveland.'

A FARM FOR SALE.

SITUATED on Blue River, three miles north of Knightstown, on the road leading from thence to Greensborough; containing 70 acres. Good Building, stock warter, 30 acres cleared and under good fence and cultivation; with 10 acres partly cleared. The undersigned, offers the said premsies for one thousand dollars, in good payments. Please call and see.
JESSE MEREDITH.
Knightstown ninth mo 22nd 1847.

Page from the minutes book of the Neel's Creek Anti-Slavery Society, which formed in Jefferson County, Indiana, on January 5, 1839, with the object of "the entire abolition of slavery in the United States." Among the Society's members were local Underground Railroad conductors Samuel H. Tibbets and Reverend Thomas Hicklin. Rare Books and Manuscripts Department, Indiana State Library.

Agreeably to notice a meeting was held in the public schoolhouse on Neel's Creek, Jefferson Co. Ia on Saturday evening, January 5th 1839, for the purpose of forming an Anti-Slavery Society. Rev. Thomas Hicklin was called to the chair, and S. C. Tibbets appointed Secretary pro tem. The object of the meeting being stated by the chairman a Constitution was presented and read, which, after some discussion and a slight amendment, was adopted as follows:

Constitution

Art. 1.—This Society shall be called the "Neel's Creek Anti-Slavery Society," auxiliary to the Indiana State Anti-Slavery Society.

Art. 2.—The object of this Society shall be the entire abolition of slavery in the United States. While it admits that each state in which slavery exists has by the Constitution of the United States, the exclusive right to legislate in regard to its abolition in said

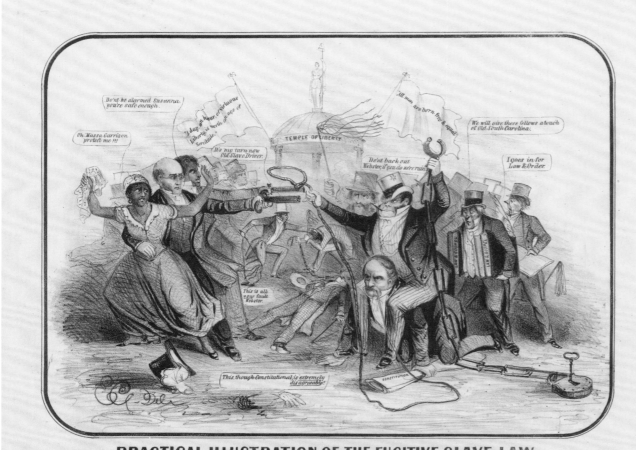

PRACTICAL ILLUSTRATION OF THE FUGITIVE SLAVE LAW.

Practical Illustration of the Fugitive Slave Law, 1851, a satirical cartoon capturing the hostility between Northern abolitionists, portrayed on the left, and supporters of the Fugitive Slave Act, on the right, including Secretary of State Daniel Webster, who bears a slave catcher on his back. Prints and Photographs Division, Library of Congress, Washington, DC.

Canada-based *Voice of the Fugitive*—edited by Henry Bibb, a former slave—often reported underground news in detail, including the passage of fugitives through town and even the names of people who had helped them. Local underground groups occasionally published broadsides and posters announcing what they were doing, to help with fundraising.

Despite the concerns of Douglass and others that the Underground Railroad would lose its effectiveness if it received too much publicity, it continued to be remarkably successful. Although most freedom seekers escaped captivity on their own, and many traveled northward for days or weeks without any assistance, very few were recaptured once they made contact with the underground. No one knows the total number of fugitives who were helped by the Underground Railroad. However, based on various local estimates, it is possible to speculate that somewhere between seventy-five thousand and a hundred thousand freedom seekers may have passed through its stations in the six decades before the Civil War. Sadly, that was only a small percentage of the total number who attempted to escape, most of whom were caught and returned to slavery, and an even smaller proportion of the four million men and women who were enslaved in the United States by 1860.

The volume of traffic on the Underground Railroad varied widely from place to place. Elijah Anderson, an African American who conducted fugitives on a busy route in southern Indiana, claimed to have handled eight hundred fugitives over an eight-year period, or about ninety per year.

Between mid-1854 and early 1855, the all-black Committee of Nine, which oversaw the Underground Railroad in Cleveland, forwarded 275 fugitives to Canada, an average of one per day. Another famous, and famously defiant, operative, Thomas Garrett of Wilmington, helped thousands of fugitives—most of them from the Eastern Shore of Maryland and Virginia—during his almost forty-year career as a stationmaster. Convicted in 1848 of abetting the escape of fugitives and subjected to a fine that virtually wiped out his hardware business, he boldly told the court, "If any of you know a slave who needs assistance, send him to me."[10] By contrast, Milton Kennedy, an ardent abolitionist who worked on an Ohio River steamboat, was disappointed to encounter just two fugitives during his years on the river.

For fugitives, there was always risk of recapture. Those who thought they were safe were sometimes snatched by professional slave hunters from their homes or places of work in New York, Boston, and elsewhere, and shipped back south. Many northern conductors and stationmasters were prosecuted under the Fugitive Slave Law, first enacted in 1793 and tightened in 1850. Conductors caught below the Mason-Dixon Line could expect no mercy. Calvin Fairbank, a divinity student from New York, was arrested for transporting a fugitive family out of Kentucky. He served thirteen years at hard labor in the state penitentiary and suffered regular flogging. Seth Concklin, another New Yorker, was murdered after his capture with a family of freedom seekers in Indiana, and his body was tossed in the Ohio River.

Americans long thought of the Underground Railroad as a racially monochromatic narrative of high-minded white people condescending to assist terrified and helpless blacks. Concklin and Fairbank, like Levi Coffin and Thomas Garrett, happened to be white. However, apart from the thousands of lives saved from slavery, the

Manifest of a slave ship
sailing from Richmond, Virginia,
to New Orleans, October 18,
1840. African American
Resource Center, New Orleans
Public Library.

underground's greatest achievement may have been its creation of a truly free zone of interracial activity where blacks not only directed complex logistical and financial operations, but also supervised networks that included white men and women who were accorded no special status because of their color. The most famous conductor of all was of course Harriet Tubman. She had escaped from slavery in Maryland in 1849 and returned there repeatedly to bring at least seventy freedom seekers to safety in the North and Canada.[11] But she was just one of many African Americans who took almost unimaginable risks on the front lines of the underground and in its leadership. William Still in Philadelphia, Lewis Hayden in Boston, George DeBaptiste in Madison, Indiana (and later Detroit), William Lambert in Detroit, David Ruggles, and Jermain Loguen all devoted their lives to service in the Underground Railroad and deserve as proud a place in the pantheon of history as Tubman and Douglass.

If the long, disheartening history of slavery showed white Americans at their worst, the history of the Underground Railroad reveals them—white and black alike—at their bravest and self-sacrificing best, as an enduring model of interracial collaboration for our own time, and for times to come.

1. Levi Coffin, *Reminiscences* (Cincinnati: Western Tract Society, 1879), 712.

2. Nancy A. Hewitt, *Women's Activism and Social Change: Rochester, New York 1822–1872* (Ithaca, NY: Cornell University Press, 1984), 150; Julie Roy Jeffrey, *The Great Silent Army of Abolitionism: Ordinary Women in the Antislavery Movement* (Chapel Hill: University of North Carolina Press, 1998), 179–84.

3. *Pennsylvania Gazette*, May 23, 1787.

4. Lydia Maria Childe, *Isaac T. Hopper: A True Life* (Boston: John P. Jewett & Co., 1853), 248.

5. Isaac Beck, interview with Wilbur H. Siebert, December 26, 1892. Wilbur H. Siebert Collection, Ohio Historical Society, Columbus, Ohio.

6. Coffin, *Reminiscences*, 109–10.

7. *Frederick Douglass' Paper*, March 7, 1854.

8. Frederick Douglass, *Autobiographies* (New York: The Library of America, 1994), 85.

9. Jay P. Smith, "Many Michigan Cities on Underground Railroad in Days of Civil War," *Detroit News*, April 14, 1918.

10. William Still, *The Underground Railroad* (Chicago: Johnson Publishing Company, 1970), 658.

11. Kate Clifford Larson, *Bound for the Promised Land: Harriet Tubman, Portrait of an American Hero* (New York: Random House, 2003), 93–96, 65–66.

Let Freedom Ring:
The Underground Railroad Comes Alive

ERIC R. JACKSON

In 1838, Frederick Augustus Washington Bailey, later known as Frederick Douglass, fled Baltimore in his second attempt at freedom. He had undertaken months of patient planning, having begun by obtaining seaman's protection papers, or "freedom papers," from a retired black sailor he had met several years earlier. Ready to "talk...like an 'old salt,'" Douglass dressed in the manner of a sailor in a red shirt, a black cravat tied in sailor fashion, and a tarpaulin hat.[1] He had Isaac Rolls, a hackman and friend, bring his baggage to the station at the last moment to avoid having his papers, which bore the description of another man, closely examined at the ticket window. As the northbound train to Philadelphia departed, Douglass jumped aboard.

Though he had made it onto the train, he knew his freedom was not yet guaranteed. Capturing the anxiety of his journey, he later wrote, "Though I was not a murderer fleeing from justice, I felt perhaps quite as miserable as such a criminal. The train was moving at a very high rate of speed for that time of railroad travel, but to my anxious mind, it was moving far too slowly. Minutes were hours, and hours were days, during this part of my flight....The heart of no fox or deer, with hungry hounds on his trail in full chase, could have beaten more anxiously or noisily than did mine, from the time I left Baltimore till I reached Philadelphia."[2]

When the train reached Havre de Grace, Maryland, Douglass disembarked with his fellow passengers and boarded a ferry to cross the Susquehanna River. Already in a state of high anxiety, he was unexpectedly engaged in conversation by a free black deckhand, Nichols, who began asking him "dangerous questions as to where I was going, and when I was coming back."[3] Douglass feared he might be recognized as a fugitive and his identity revealed. Fortunately, he was able to end the conversation quickly.

From the ferry, Douglass boarded another train, this one bound for Wilmington, Delaware. As it slowed and stopped next to a southbound train, Douglass looked to the window opposite and saw Captain McGowan from the Baltimore shipyards, where Douglass had worked only a few days before. He felt sure the captain would recognize him, but after a harrowing moment, the trains departed.

In another hairbreadth escape, Douglass recognized a German blacksmith he knew well. The man stared at him intently, but said nothing. "I really believe he knew me," wrote Douglass, "but had no heart to betray me. At any rate he saw me escaping and held his peace."[4] From Wilmington, "the last point of imminent danger, and the one I dreaded most," Douglass boarded a steamboat for Philadelphia, City of Brotherly Love, and then traveled overnight to New York. He later recalled, "I reached New York on Tuesday morning, having completed the journey in less than twenty-four hours. Such [was] the manner of my escape from slavery — and the end of my experience as a slave."[5]

A few years later, on an overcast night in 1842, John P. Parker snuck aboard a steamship he hoped would take him to freedom. A previous attempt to escape had failed, and this attempt, which had already brought him from Mobile, Alabama, to Vicksburg, Mississippi, would be no more successful. Parker was captured aboard the ship and taken to a New Orleans jail. Refusing to divulge where he had come from or the name of his master, he remained there for ten months, planning his escape. Finally he was readied for auction, outfitted in new clothes, and brought to a slave pen. There, Parker carefully assessed his surroundings and at an opportune moment hid in a blind spot in the pen until he could evade his jailer and sneak away. In his good clothes and ambling calmly, Parker raised no suspicion as he made his way to the Mississippi River. He sat on a barrel of flour to contemplate his plans for the future, when "a hand touched my shoulder. Looking up, I stared right into the eyes of my owner, the doctor from Mobile. All he said was: 'Well, well.'"[6]

Parker returned with his master to Mobile and worked at various foundries as an iron molder. After a time, he entered into a contract with a patient of the doctor's, a widow named Mrs. Ryder, who had reluctantly agreed to purchase him in order to allow him time to earn wages to pay the $1,800, plus interest, for his freedom. After several months, Parker was able to buy his freedom. With his papers sewn into his clothes, he traveled to New Albany, Indiana, then Cincinnati, Ohio, and finally Ripley, Ohio. Once in Ripley, Parker, along with the white radical Presbyterian minister and abolitionist Reverend John Rankin, began several decades of activity with the Underground Railroad that helped deliver thousands of enslaved African Americans to freedom. Together Parker and Rankin ferried fugitives across the Ohio River and used Rankin's home, perched high on the bluffs, as a safe house visible for many miles along the river.

On a winter night in 1838, Eliza Harris plotted her escape from Maysville, Kentucky. Harris had had three children, but had lost two in infancy. When a slave trader appeared at her master's estate to negotiate her purchase, which would separate her from her remaining child, who was then just two years old, Harris took action. She wrapped her son in a shawl and quickly fled on foot down the Tuckahoe Ridge toward

the Ohio River. Reaching the river, her first step onto the ice broke through, but, desperate, Harris clutched her son close, holding him to her cheek, and frantically crawled and clambered across the hunks of ice, her legs plunging into the frigid water. Reaching the other side, she found safety at the Rankin farmhouse in Ripley and was subsequently sent west, passing through Levi and Catherine Coffin's home and continuing along the Underground Railroad north to freedom.

Douglass, Parker, and Harris are just a few among the thousands of enslaved black Americans who sought emancipation from human bondage. This drive for freedom had become more complicated when the United States Constitution was ratified with a provision that protected the institution of slavery from federal interference, and with the passing of the Fugitive Slave Acts of 1793 and 1850, which not only gave slaveholders the right to pursue and recapture runaway slaves anywhere in the United States, but criminalized the assistance of slaves in escaping. Despite these decrees, people of different races, religions, and social classes—blacks and whites, rich and poor, Christians and non-Christians, women and men—consistently broke the law to assist black Americans in their quest for liberation. Indeed, several scholars have described it as the first multiracial, multiclass, multiethnic civil rights movement in the history of the United States.

The Underground Railroad remains historically significant in the minds and hearts of Americans. Beyond its well-deserved place in history, its social relevance today cannot be underestimated.

———

1. Frederick Douglass, *The Life and Times of Frederick Douglass: From 1817–1882, Written by Himself; with an Introduction by the Right Hon. John Bright,* ed. John Lobb (London: Christian Age Office, 1882), 167.

2. Ibid., 168.

3. Ibid., 169.

4. Ibid.

5. Ibid.

6. John P. Parker, *His Promised Land: The Autobiography of John P. Parker, Former Slave and Conductor on the Underground Railroad,* ed. Stuart Seely Sprague (New York: W. W. Norton & Company, 1996), 63.

The songs of a slave represent the sorrows of his heart;

and he is relieved by them, only as an aching heart

is relieved by its tears.

—FREDERICK DOUGLASS

The Spirituals

ROBERT F. DARDEN

The spirituals were the Underground Railroad's catalyst, a siren's call, a transformative change agent of unassuming sophistication and haunting beauty. They were sung under the noses of the oppressors and—God willing—in the presence of the liberators. The spirituals powered the Underground Railroad.

"Go Down, Moses," the best-known spiritual, was associated with Harriet Tubman, a tiny, feisty, fearless "conductor" of the Railroad. Tubman helped liberate hundreds of former slaves while risking her own freedom. Her early biographers write that she sang the song as she guided her charges through dark woods and into forbidding nights:

Oh Pharaoh said he would go 'cross,
Let my people go.
And don't get lost in de wilderness,
Let my people go.

You may hinder me here, but you can't up dere,
Let my people go.
He sits in de Hebben and answers prayer,
Let my people go.

A second spiritual sometimes associated with Tubman is "Swing Low, Sweet Chariot." Numerous spirituals describe a great golden vehicle, a "gospel train," powered by faith and conducted by the Almighty. It is potent imagery even today. This chariot, this train, is heading north to freedom:

I look'd over Jordan, an' what did I see?
Comin' for to carry me home,
A band of angels comin' after me,
Comin' for to carry me home.

Academics and scholars argue over how many of the six thousand known spirituals were actually songs of protest. In the double-voicedness of the slave, which allowed the

slave-poet to sing with impunity within earshot of the overseer, perhaps every spiritual could be construed to be a freedom song.

Some spirituals were very clearly affiliated with escape. "Foller the Drinkin' Gourd," that otherworldly chant with its distinctive African melody, was later purported to be a detailed oral map guiding slaves from the plantations of the Tombigbee River northward by following the Big Dipper—the drinking gourd of the title. "Wade in the Water" was believed to contain instructions for throwing bloodhounds off the trail of an escaped slave. And the insurrectionist Nat Turner—along with untold thousands after him—used "Steal Away" to signal to his followers that it was time to leave.

Still other spirituals are redolent of possibilities, secret and sometimes not-so-secret clarion calls, meant to both encourage and inspire those with ears to hear:

Run, Mary, run
Run, Mary, run
I know de udder worl' is not like dis.
I'm goin' to eat at the welcome table,
Oh yes, I'm goin' to eat at the welcome table some of
these days, hallelujah!
O, wasn't dat a wide river…wide-river!
Dere's one mo' river to cross.
Run to Jesus, shun the danger,
I don't expect to stay much longer here.

In the end, the particulars remain unknown. Were the spirituals sung as the refugees trudged through swamps or picked their way through primordial forests? It could be that the danger of discovery was too great, as no one wanted the bounty hunters, the patterrollers and their dogs, to hear and follow. Perhaps the singing was reserved for the beginning of the journey and only resumed when the former slaves were safely across the Ohio River.

Perhaps the songs were sung while resting in the homes and barns and sheds along the Underground Railroad, softly and sweetly, as a benediction. Or maybe these precious words were sung every step of the way. "Every tone," wrote Frederick Douglass of the spirituals, "was a testimony against slavery, and a prayer to God for deliverance from chains." How could you keep from singing?

This world's a wilderness of woe,
So let us to glory go.

"My way's cloudy," some former slave may have sung in a voice barely above a whisper, "Go sen'-a dem angels down."

But whether the spirituals were sung before, during, or after the journey—or all of the above—they were sung. Make no mistake.

I believe this because they are still being sung by those needing guidance and support, encouragement and succor, faith and transcendence. They were sung at the Berlin Wall, in Tiananmen Square, in the countries of the Arab Spring, and in the streets of Hong Kong's Umbrella Revolution.

The freedom spirituals are still being sung because there is freedom yet to be won, just as the Underground Railroad, in some form or another, still runs because there are those who still need deliverance.

My Lord calls me, He calls me by the thunder;
The trumpet sounds within-a my soul,
I ain't got long to stay here!

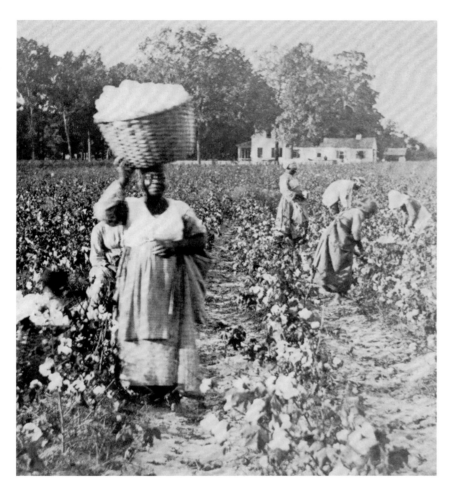

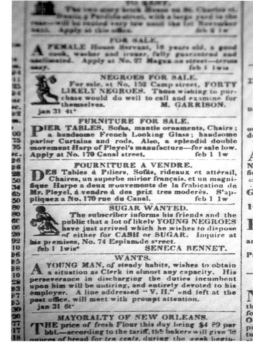

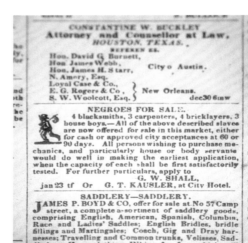

Slaves picking cotton in South Carolina, c. 1860. Rob Oechsle Collection.

Advertisement offering slaves in exchange for cash or sugar in *The Daily Picayune*, February 4, 1840. Louisiana Division/ City Archives, New Orleans Public Library.

Advertisement announcing "Negroes for Sale" and listing their trades in *The Daily Picayune*, February 5, 1840. Louisiana Division/City Archives, New Orleans Public Library.

THE JOURNEY:
A PHOTOGRAPHIC ESSAY

M uch has been written about the Underground Railroad, but there is scant visual documentation. The goal of this photographic series is to evoke a sense of one journey out of bondage: to capture what it may have felt like to run in fear for roughly three months in pursuit of freedom.

For those seeking emancipation, there were countless routes, forged both alone and with the help of the Underground Railroad. The 1,400-mile path from Louisiana to Ontario documented in these photographs is represented by the sites through which freedom seekers passed or that offered them respite during their journey northward. I pieced it together from books and original documents from the period, academic papers, and a multitude of other sources compiled or written by historians of slavery and the Underground Railroad (notes on individual photographs can be found on page 184). Some locations are based on word-of-mouth descriptions and oral histories. In these instances, I applied careful consideration and did further research. Sometimes I uncovered supporting documentation, but other times none was found. But to disregard these sites is as fraught as including them, as the verbal transmission of information was integral to the Underground Railroad. From the veil of secrecy surrounding the Underground Railroad, new material is still coming to light.

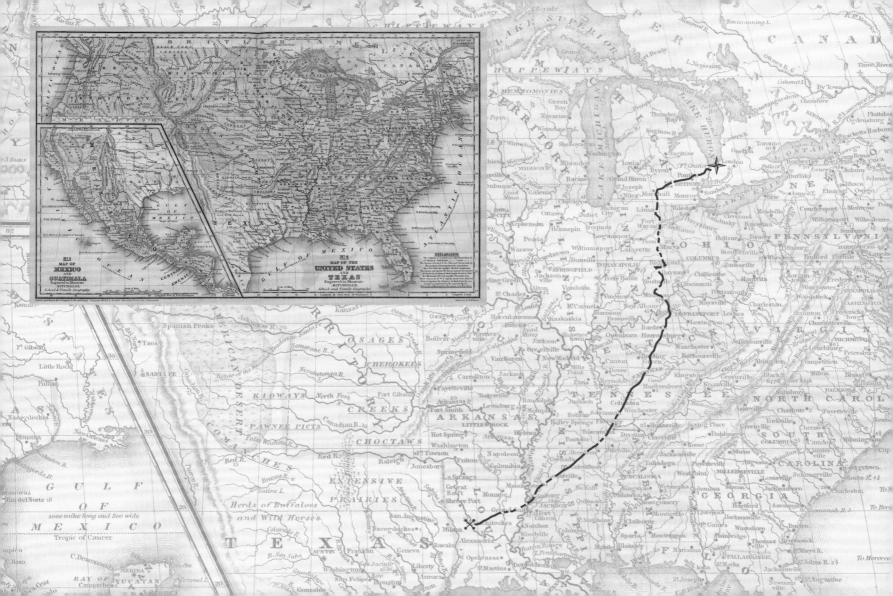

No man can tell the intense agony which was felt by the slave,

when wavering on the point of making his escape.

All that he has is at stake; and even that which he has not,

is at stake, also. The life which he has, may be lost,

and the liberty which he seeks, may not be granted.

—FREDERICK DOUGLASS

They worked me all de day, Widout one cent of pay;
So I took my flight in the middle ob de night,
When de moon am gone away.

—CHORUS OF A SONG FROM ABOLITIONIST
GEORGE W. CLARK'S *THE LIBERTY MINSTREL*, 1844

Decision to Leave. Magnolia Plantation on the Cane River, Louisiana, 2013

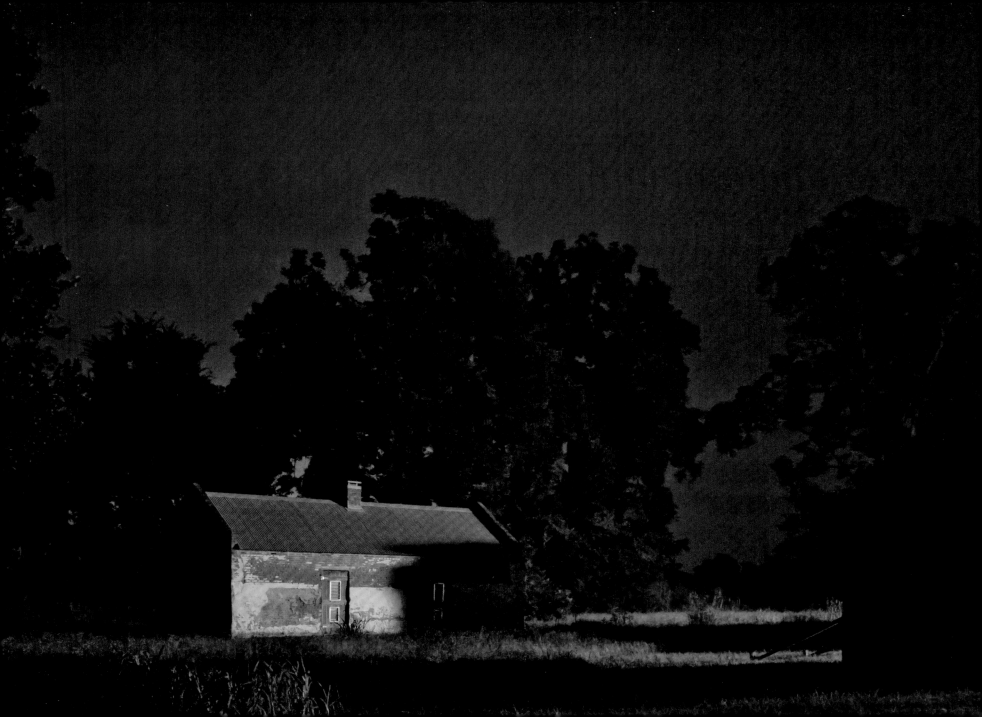

Run, Mary, run; Oh, run Mary, run:

I know the other world is not like this.

—AFRICAN-AMERICAN SPIRITUAL

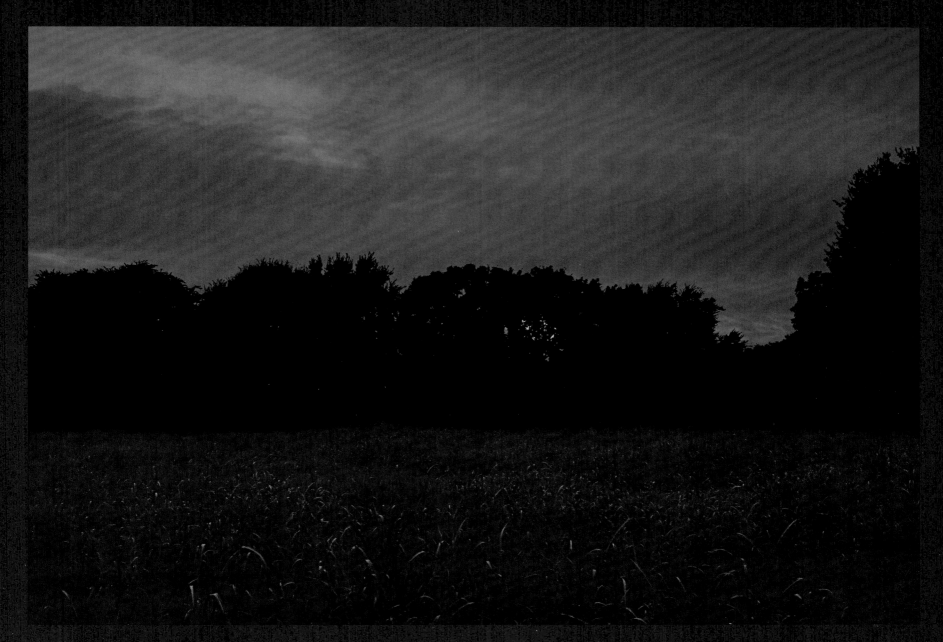

On the Run. North of the Cane River Plantations, Louisiana, 2013

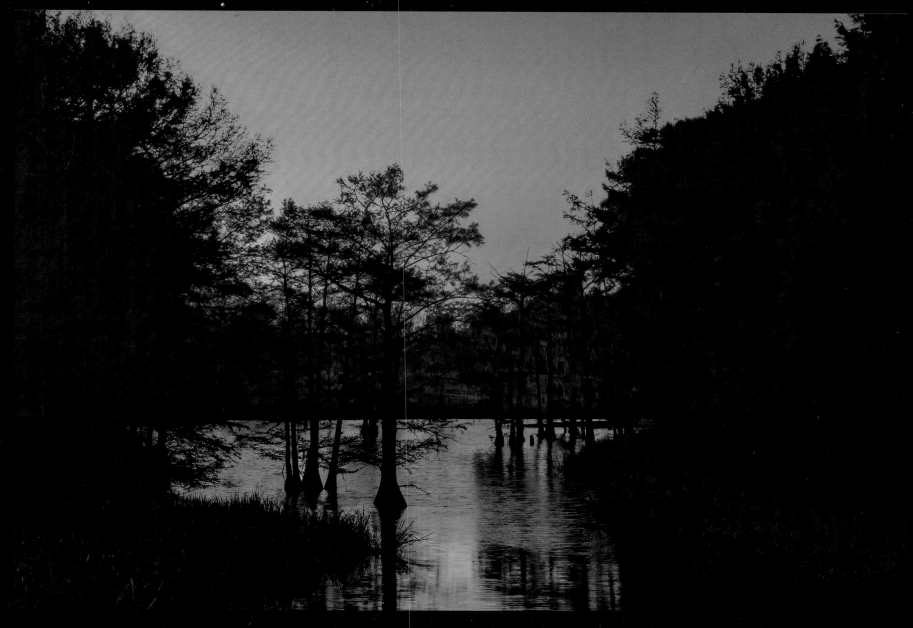

Wading Prior to Blackness. Grant Parish, Louisiana, 2014

Southern Pine Forest. Following El Camino Real, LaSalle Parish, Louisiana, 2014

Catching a Breath. LaSalle Parish, Louisiana, 2014

Black River Crossing. Continuing along El Camino Real, Catahoula Parish, Louisiana, 2014

'Tisn't he who has stood and looked on that can tell

you what slavery is—'tis he who has endured.

—JOHN LITTLE, FUGITIVE SLAVE

Stopover. Frogmore Plantation, Concordia Parish, Louisiana, 2014

Bog. Catahoula Parish, Louisiana, 2014

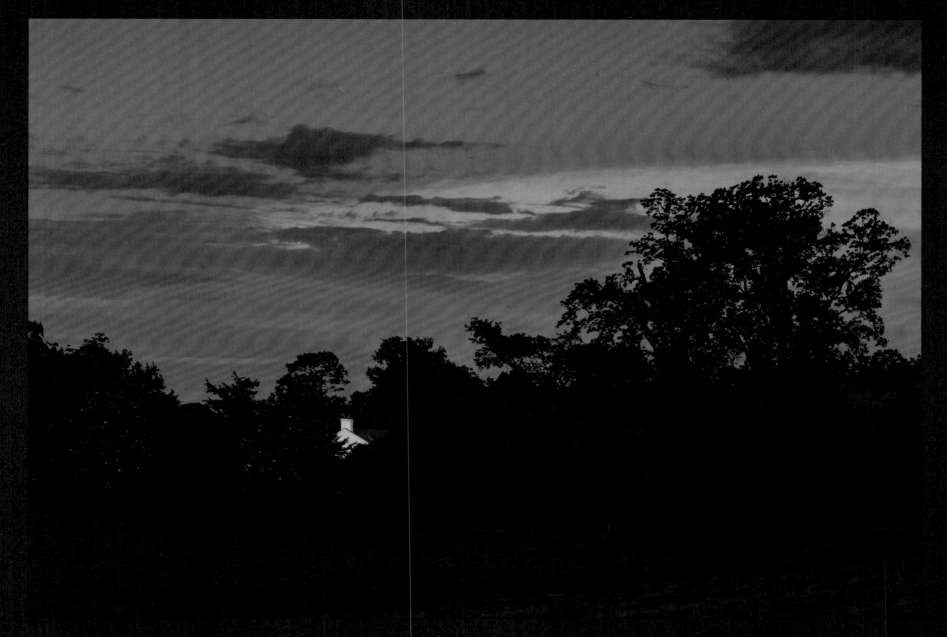

Gathering Provisions. Outskirts of the Myrtle Grove Plantation, Tensas Parish, Louisiana, 2014

Brothers and sisters we were by blood;
but slavery had made us strangers. I heard the words brother and sister,
and knew they must mean something; but slavery robbed
these terms of their true meaning.

—FREDERICK DOUGLASS

Moonlight Over the Mississippi. Tensas Parish, Louisiana, 2014

Through the Forest. Jefferson County, Mississippi, 2014

Resting Place. Church Hill, Mississippi, 2014

Hiding Out Back. Slave cemetery, Mount Locust Stand and Plantation, Jefferson County, Mississippi, 2014

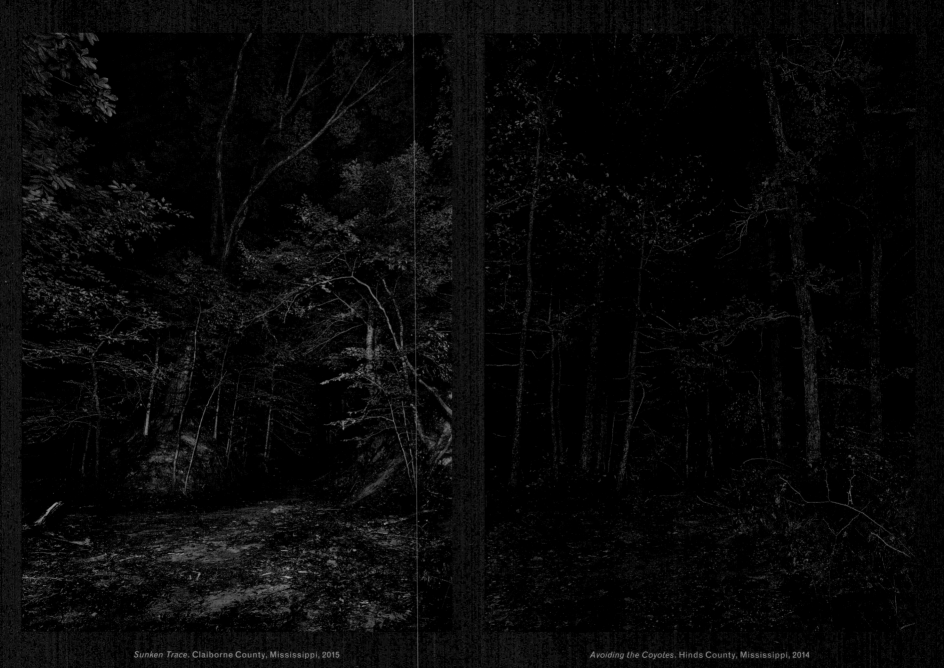

Sunken Trace. Claiborne County, Mississippi, 2015

Avoiding the Coyotes. Hinds County, Mississippi, 2014

A local grocer heard that the Smiths were mistreating their slaves.

He showed Cummings a map of Lake Erie, spoke with him about Ohio and Indiana,

taught him to find the North Star and determine direction

by moss on the tree, and encouraged him to make a run for it.

In July 1839, Cummings fled.

—ACCOUNT OF THE ESCAPE OF REVEREND JACOB CUMMINGS

Determining True North in the Rain. Along the southern part of the Old Natchez Trace, Mississippi, 2014

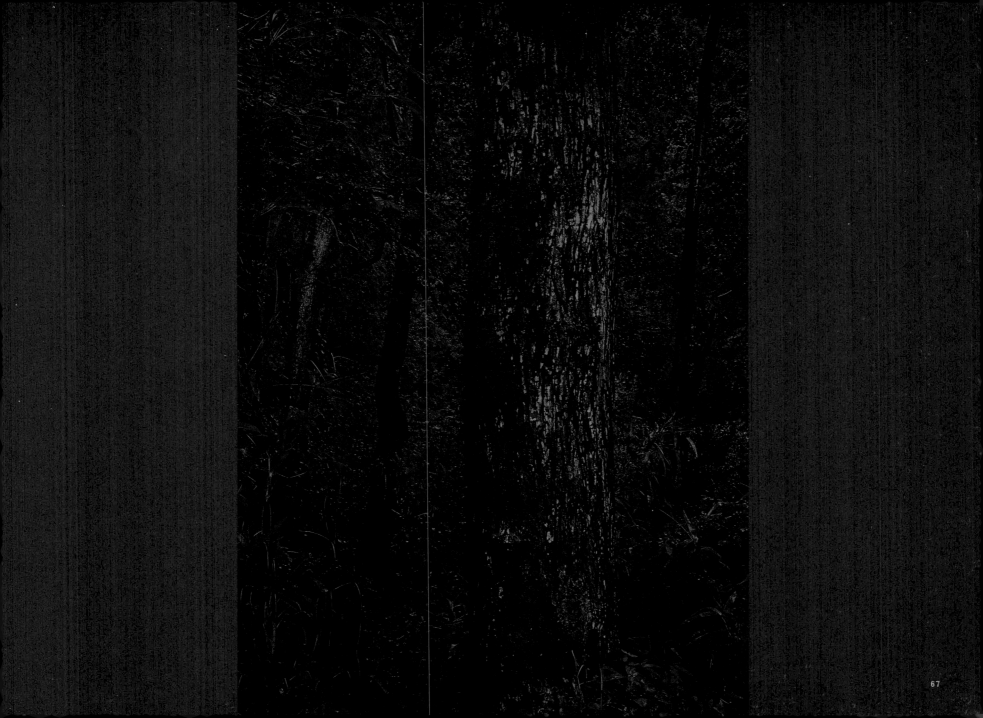

Tracking the Deer. Skirting the Osburn Stand, Mississippi, 2014

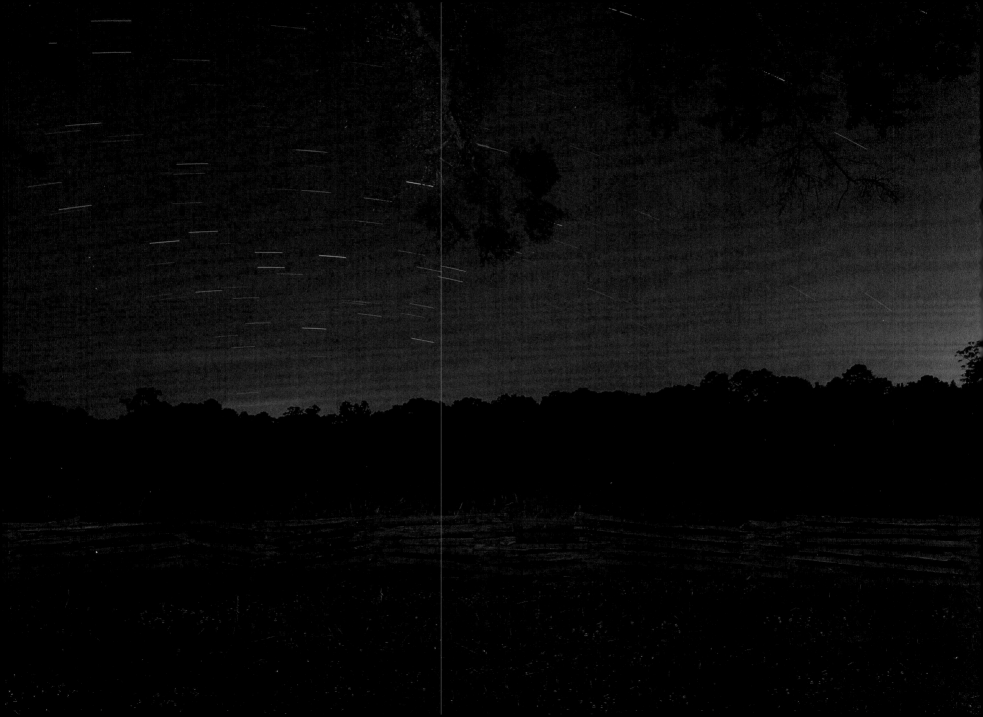

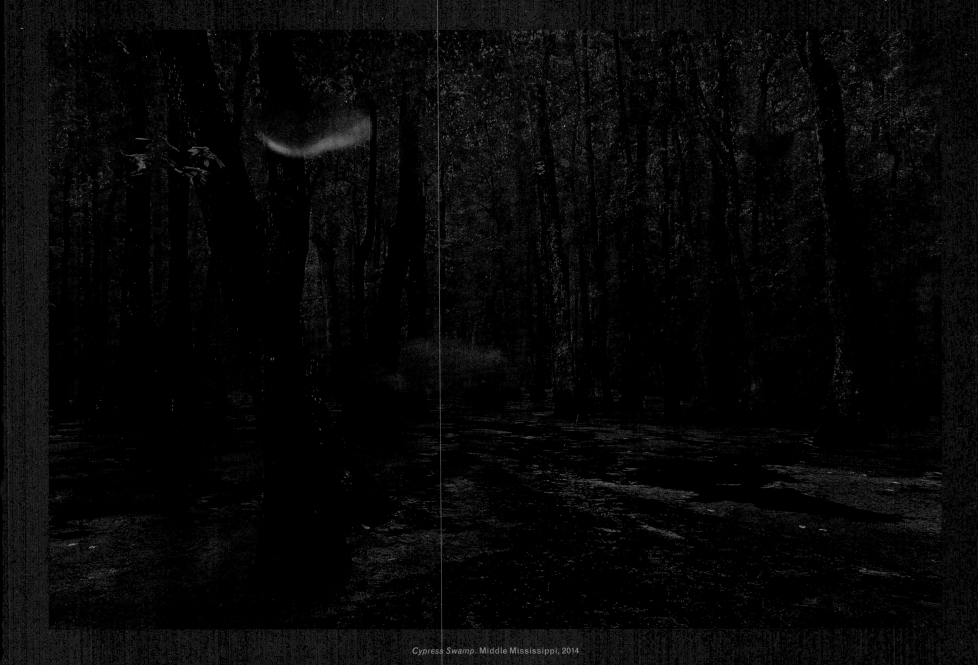

Cypress Swamp. Middle Mississippi, 2014

The conveyance most used on the southern section is known as the
"Foot and Walker Line," the passengers running their own trains,
steering by the North Star, and swimming rivers
when no boat could be borrowed.

—THE *CENSOR*, AN ANTI-SLAVERY WEEKLY, FEBRUARY 26, 1868

Off the Beaten Path. Along the Yockanookany River, Mississippi, 2014

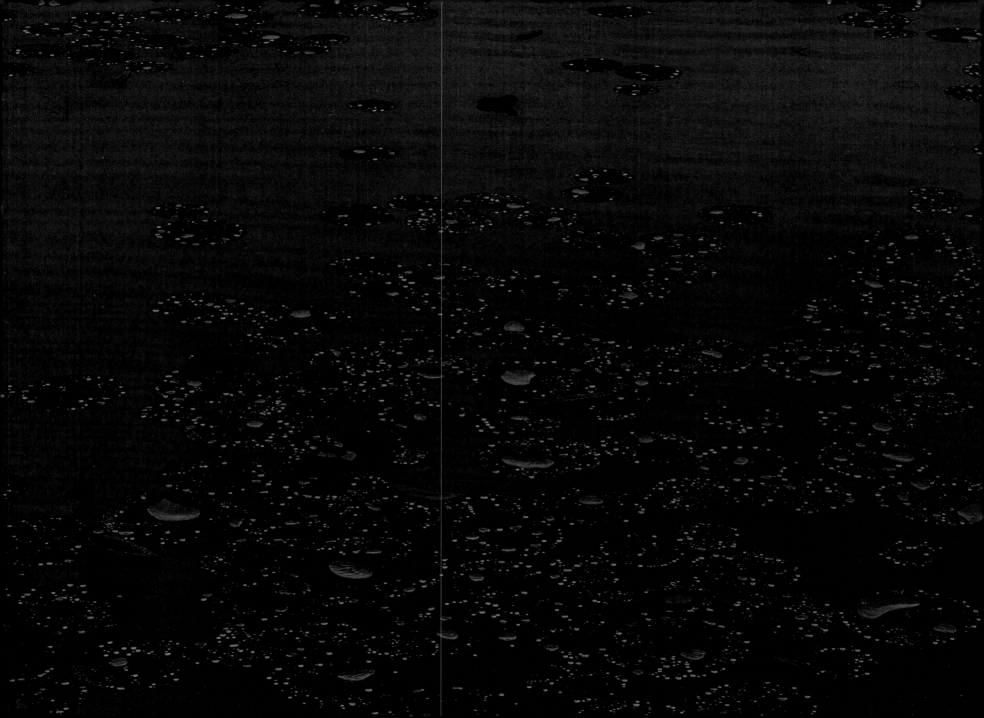

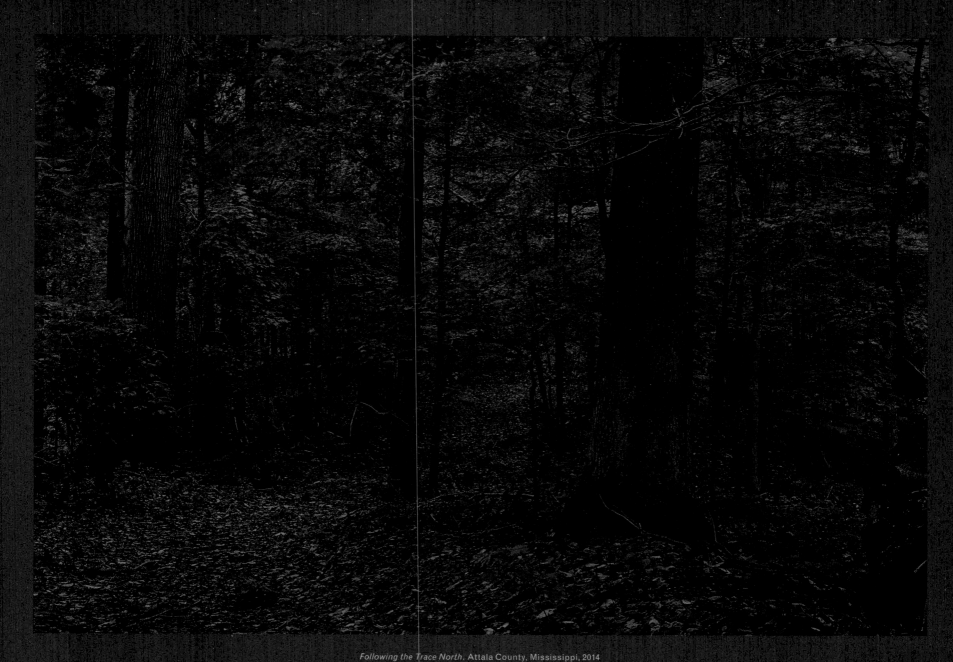

Following the Trace North, Attala County, Mississippi, 2014

Now these dogs bit me all over while some of them had hold of my legs

the others was biting on my arms, hands and throat.

I could not fall for while some of them would pull me one way, the rest would pull me the other way.

He made them bite me four or five minutes. Now these hounds was so trained to bite

without tearing the flesh, any one might think after biting four or five minutes and seven

of them at that, that they would have torned the flesh to pieces, but they would not tear the flesh out.

So when he thought that they had bitten me enough, he made them stop

and then he asked me who did I belong to. I told him.

—WALLACE TURNAGE, FORMER SLAVE

Doubling Back. Webster County, Mississippi, 2015

From Whence We Came. Following Robinson Road, Mississippi, 2014

Stopping for Directions. Meadow Woods Plantation, Oktibbeha, Mississippi, 2014

Crawling Ahead. Chickasaw County, Mississippi, 2014

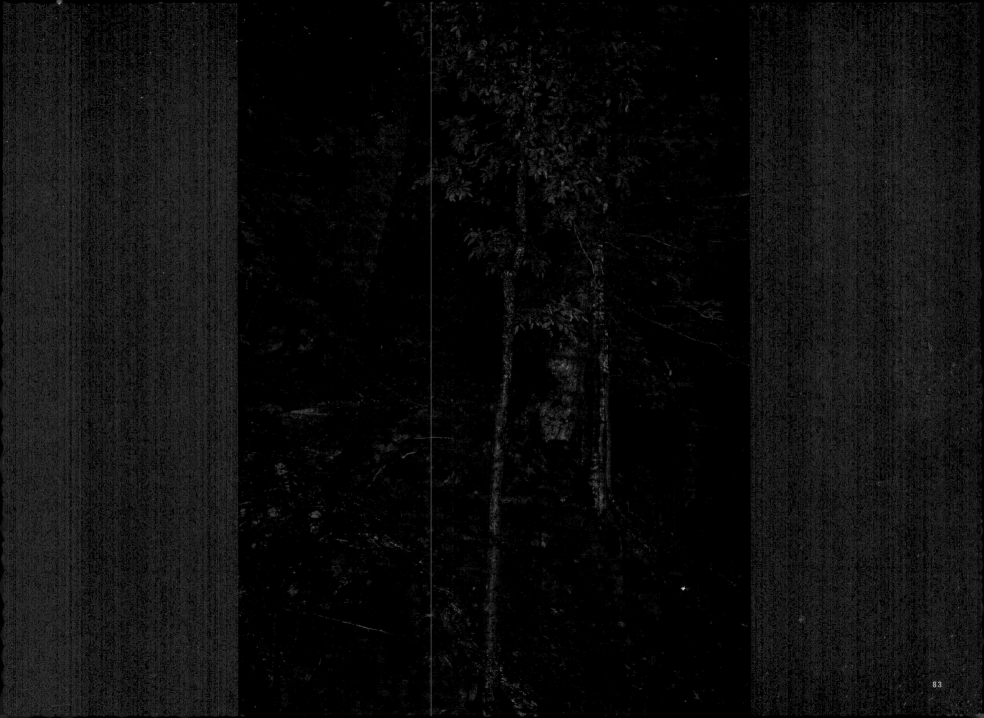

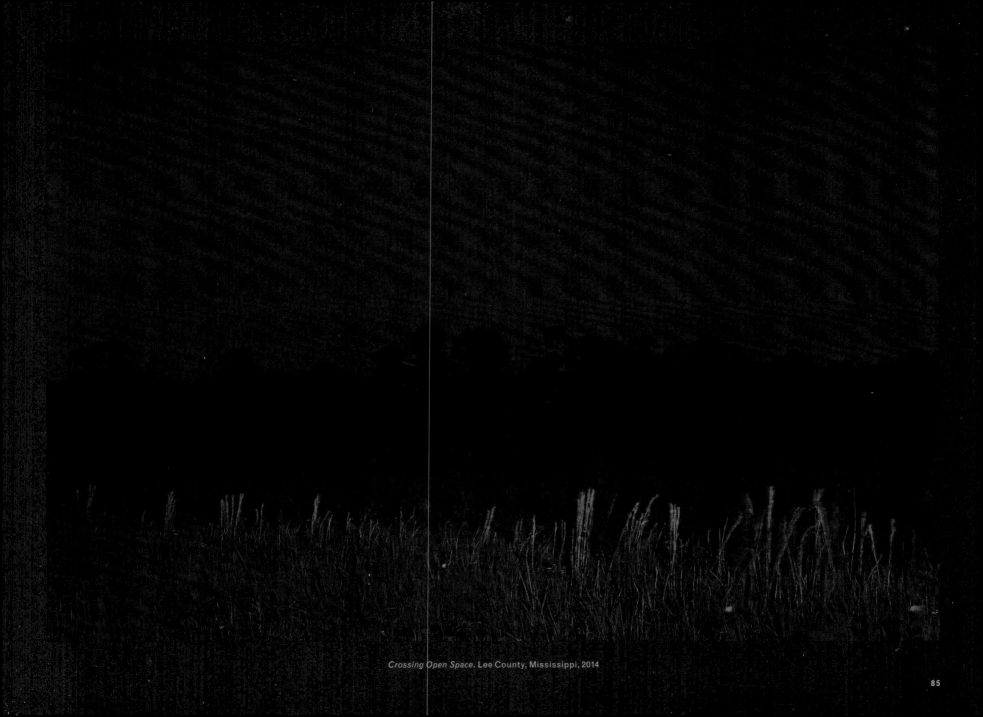

Crossing Open Space. Lee County, Mississippi, 2014

A keen observer might have detected in our repeated singing of
"O Canaan, sweet Canaan I am bound for the
land of Canaan," something more than a hope of reaching heaven.
We meant to reach the North *and the North was our Canaan.*

—FREDERICK DOUGLASS

Keep Going. Crossing the Tennessee River, Colbert County, Alabama, 2014

It would be interesting to follow this heroic girl through her long,
lonely journey through Alabama, Tennessee, and Kentucky to the Ohio River,
sometimes camping in woods and swamps in the daytime
and traveling by the North Star in the night, occasionally finding a resting place
in a negro's cabin, hungry, weary and footsore.

—AS TOLD BY EBER M. PETTIT ABOUT ONEDA LACKLOW,
A FORMER SLAVE LIVING IN CANADA

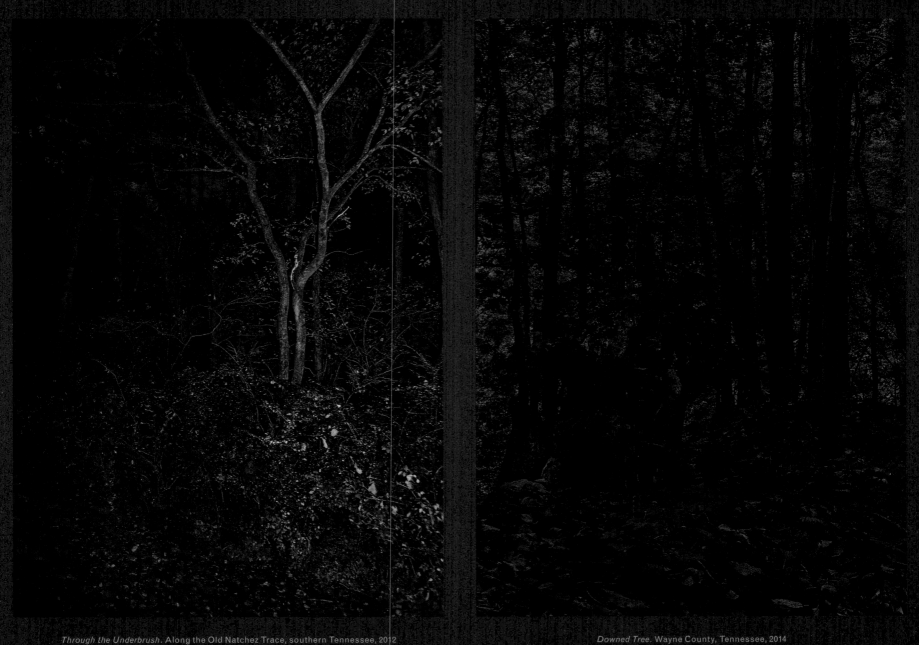

Through the Underbrush. Along the Old Natchez Trace, southern Tennessee, 2012

Downed Tree. Wayne County, Tennessee, 2014

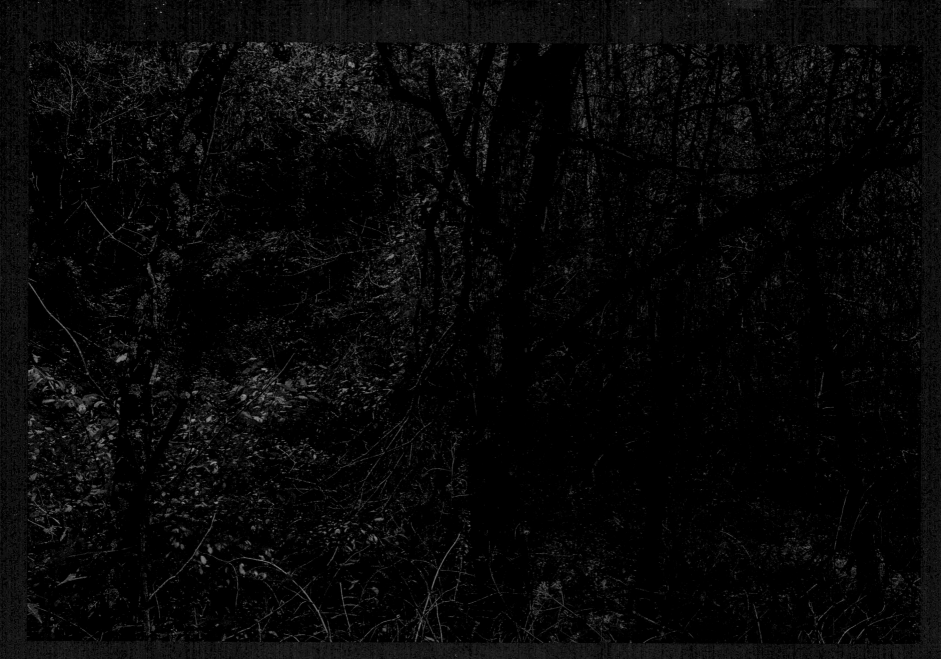

Twisted Thicket. Lawrence County, Tennessee, 2014

Devil's Backbone. Lewis County, Tennessee, 2014

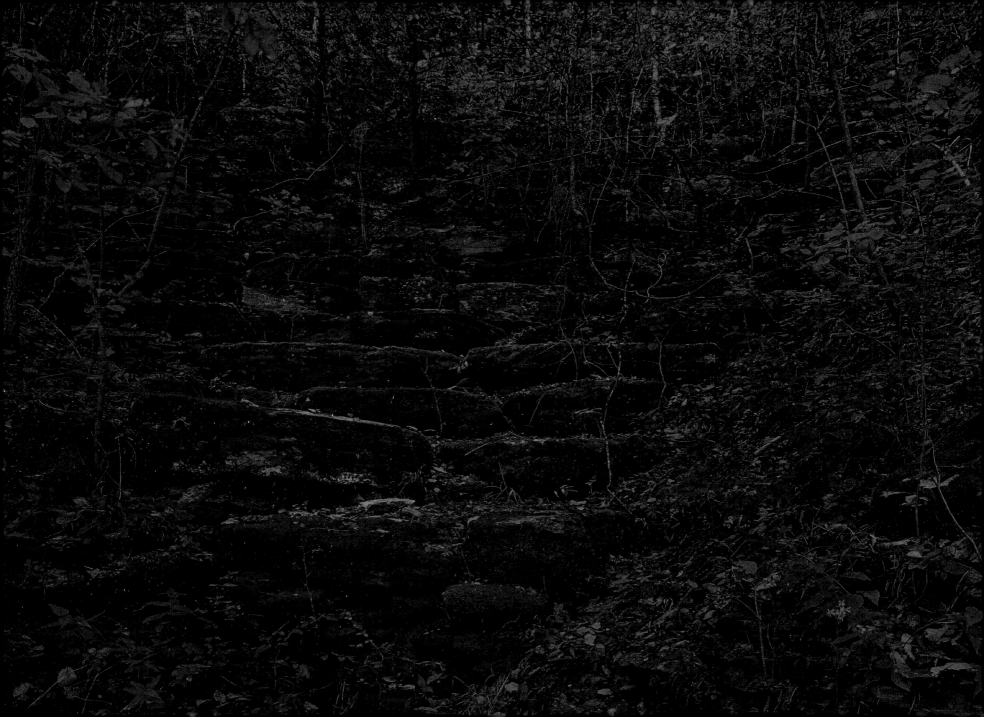

The man I called "Master" was my half brother.

My mother was a better woman than his, and I was the smartest boy of the two,

but while he had a right smart chance at school, I was whipped

if I asked the name of the letters that spell the name

of the God that made us both of one blood.

—WILLIAM, SLAVE AND HALF BROTHER TO
A UNITED STATES SENATOR

Shelter from the Storm. Hickman County, Tennessee, 2014

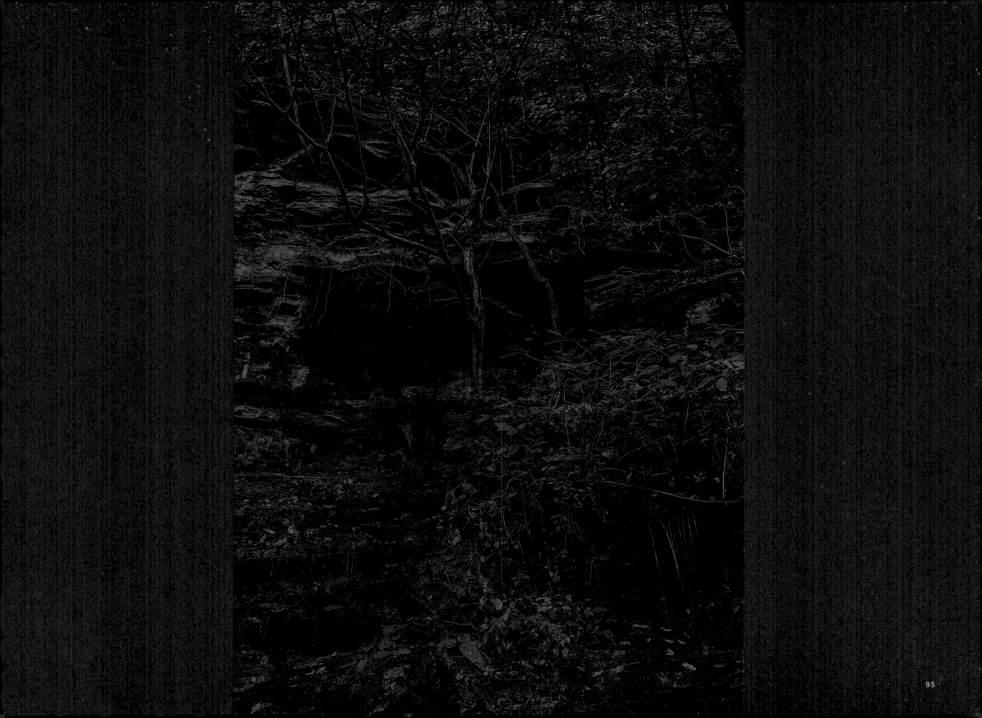

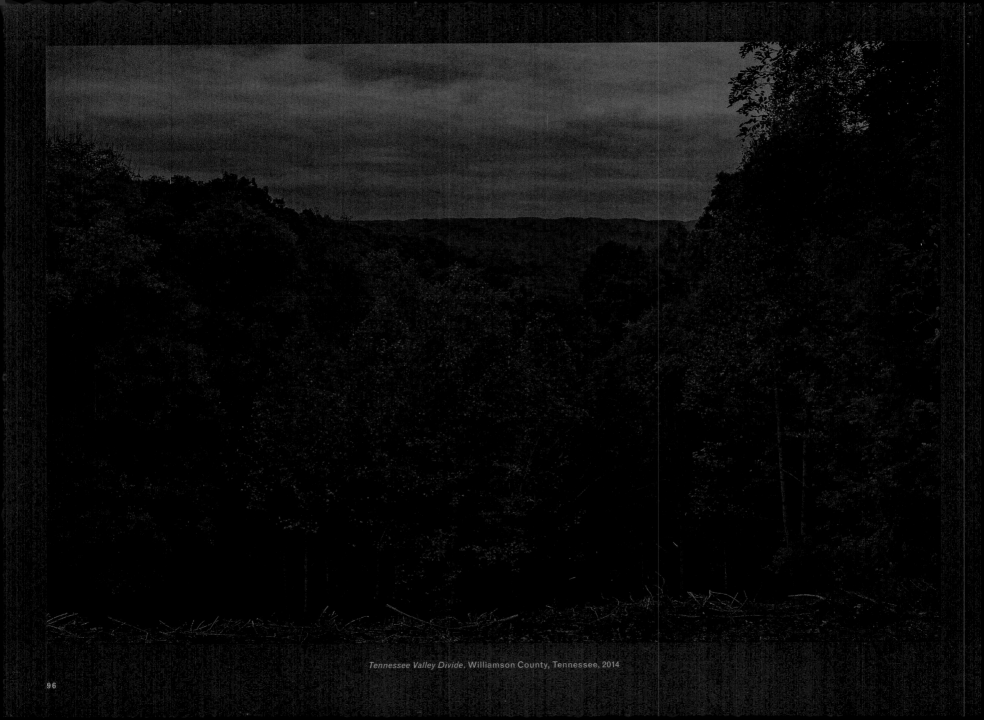

Tennessee Valley Divide. Williamson County, Tennessee, 2014

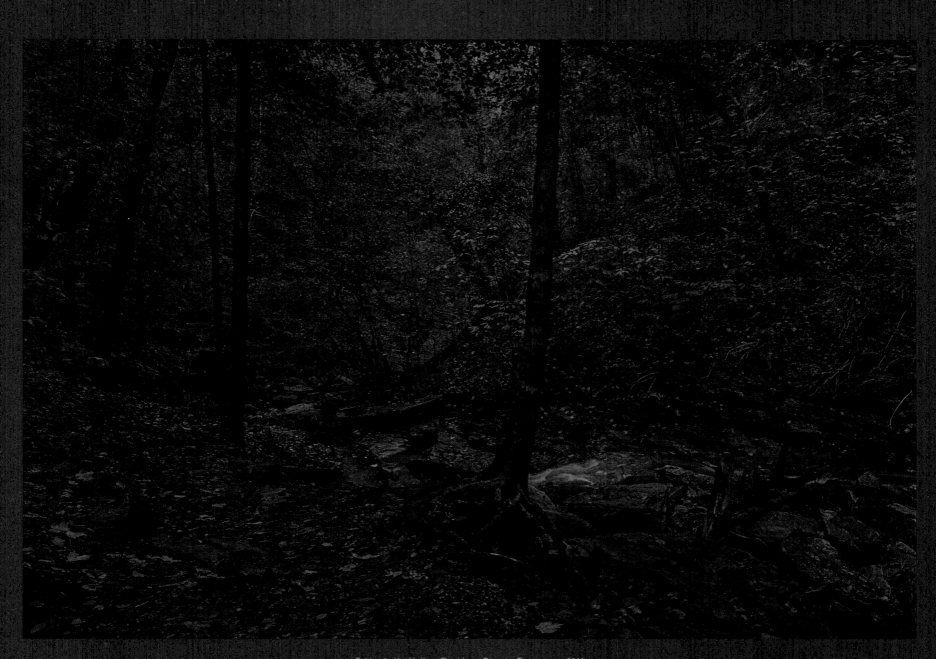

Taking to the Hollow. Davidson County, Tennessee, 2014

Hidden in Plain Sight. Rose Mont Plantation, Sumner County, Tennessee, 2014

Where Moses (he said they called him Mose) lived,

the slaves were partially educated. Their mothers taught them

a short lesson in astronomy, namely, the position

of the North Star and how to find it.

—AS TOLD BY EBER M. PETTIT ABOUT MOSES, A FORMER SLAVE LIVING IN CANADA

A Lesson in Astronomy. Southern Kentucky, 2014

I had reasoned this out in my mind;

there was one of two things I had a right to, liberty or death;

if I could not have one, I would have the other;

for no man should take me alive;

I should fight for my liberty as long as strength lasted,

and when the time came for me to go, the Lord would let them take me.

—HARRIET TUBMAN

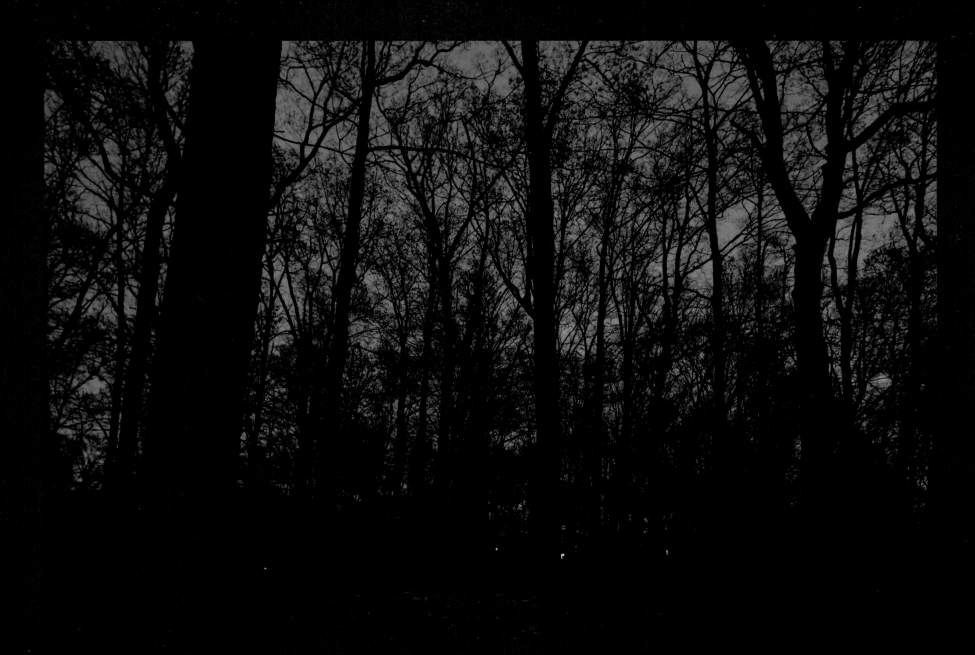

Fleeing the Torches. Warren County, Kentucky, 2014

Hidden Passage. Mammoth Cave, Barren County, Kentucky, 2014

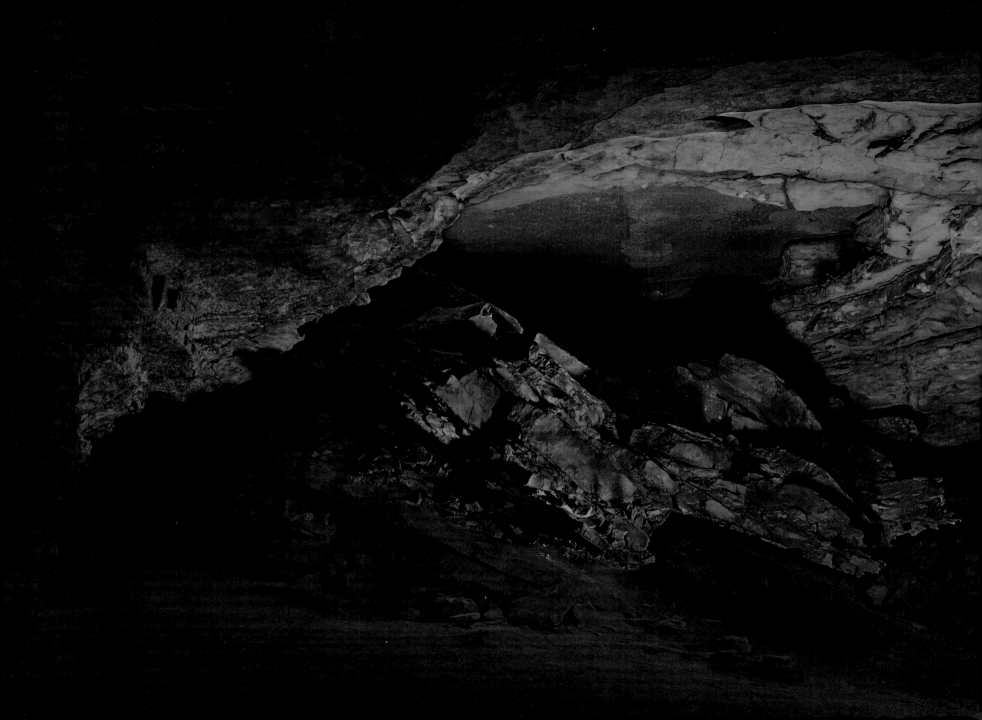

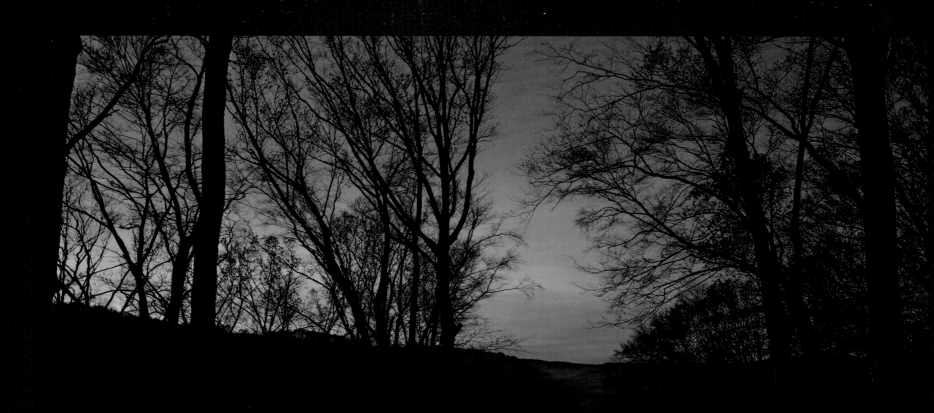

Following the Green River. Edmonson County, Kentucky, 2014

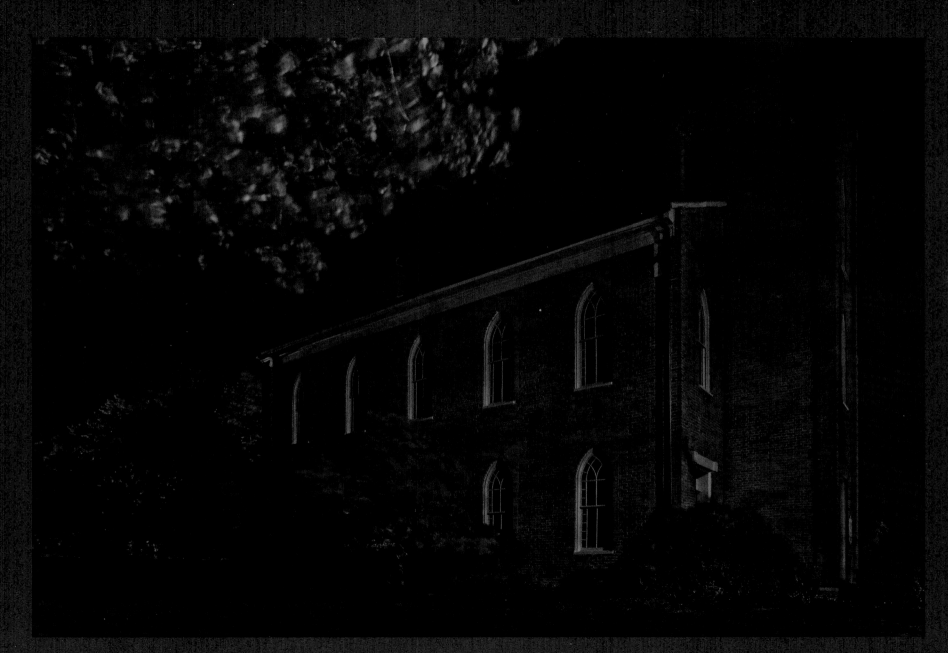

Secret Tunnels. Munfordville Presbyterian Church, Munfordville, Kentucky, 2014

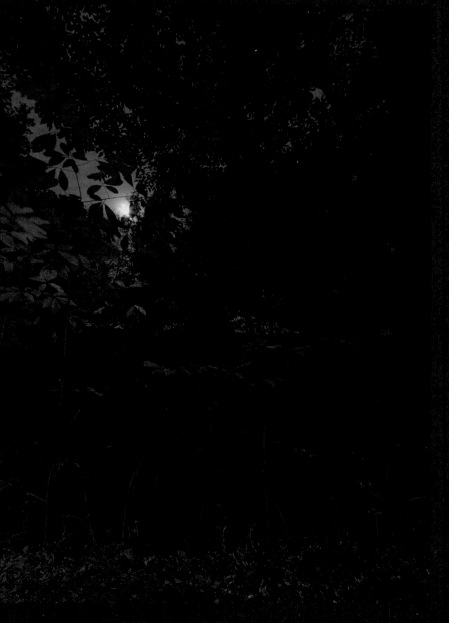

Old Man Moon. Hardin County, Kentucky, 2014

Into the Night. Spencer County, Kentucky, 2014

Racing the Stars. Between Oldham and Shelby Counties, Kentucky, 2014

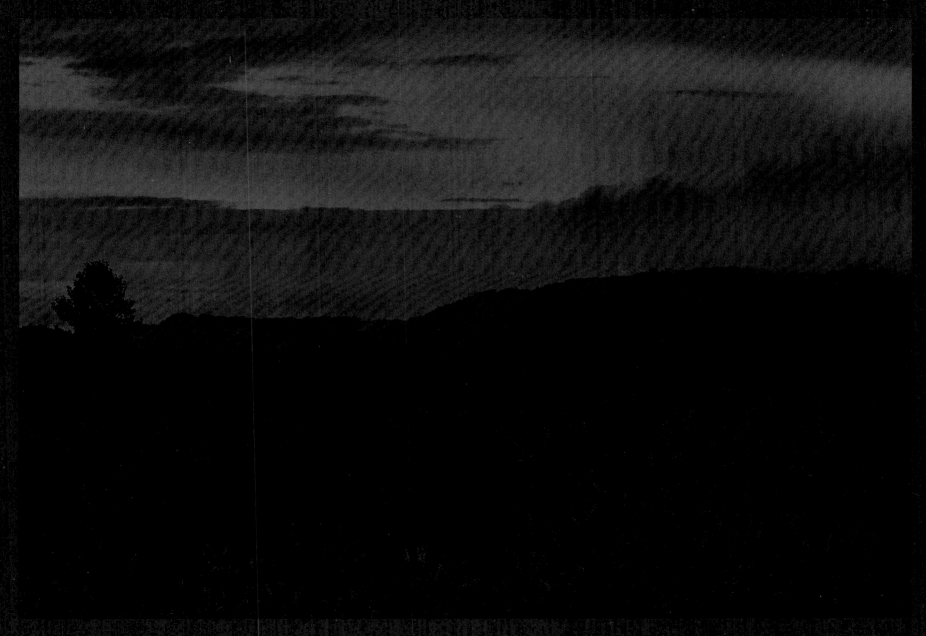

Over the Hills, North Trimble County, Kentucky, 2014

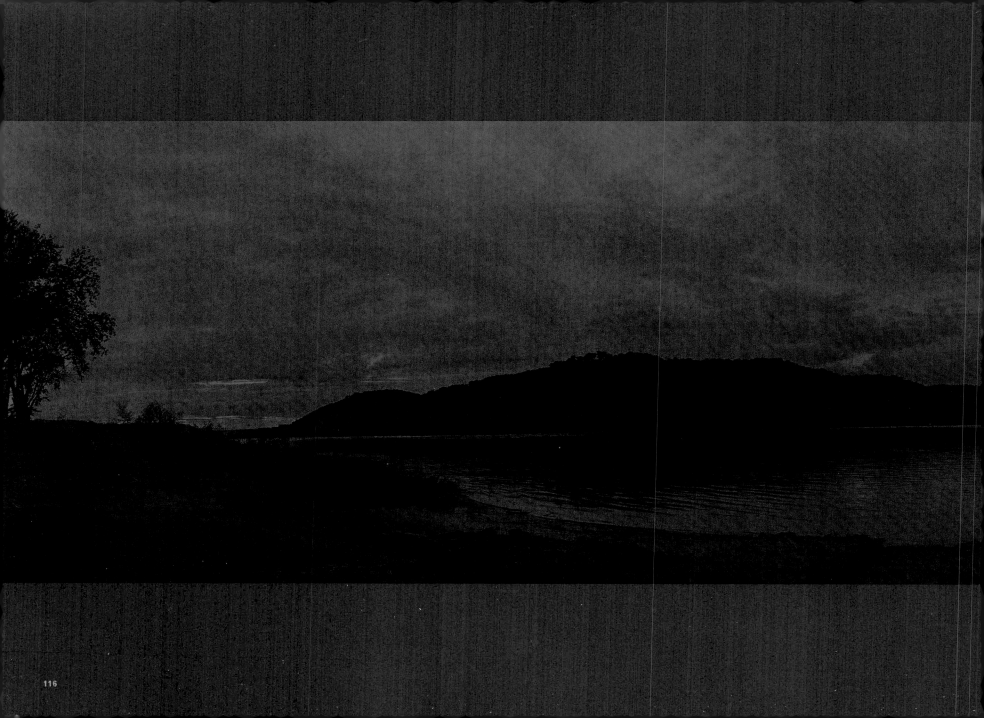

The River Jordan. First view of a free state, crossing the Ohio River to Indiana, 2014

Eagle Hollow from Hunter's Bottom. Just across the Ohio River, Indiana, 2014

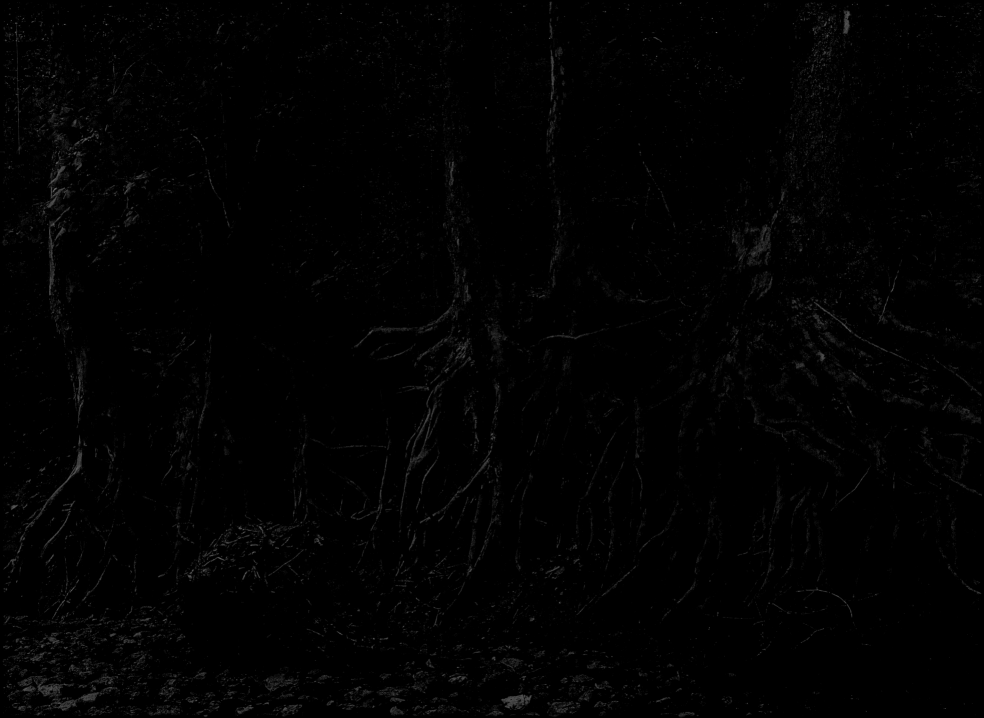

Dr. Lott's House. Georgetown District of Madison, Indiana, 2013

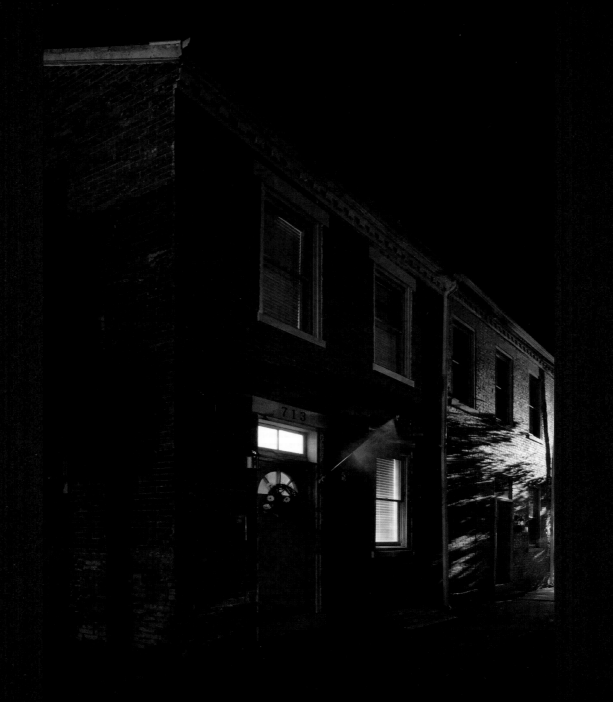

After dark I drove to the place agreed upon to meet in a piece of woods

one mile from the town of Wirt. I had been at the appointed place but a very short time

when Mr. DeBaptiste sang out, "Here is $10,000 from Hunter's Bottom tonight."

A good Negro at that time would fetch from $1,000 up.

We loaded them in…and started with the cargo of human charges towards the North Star.

—JOHN H. TIBBETS ON AN ASSIGNMENT WITH THE UNDERGROUND RAILROAD

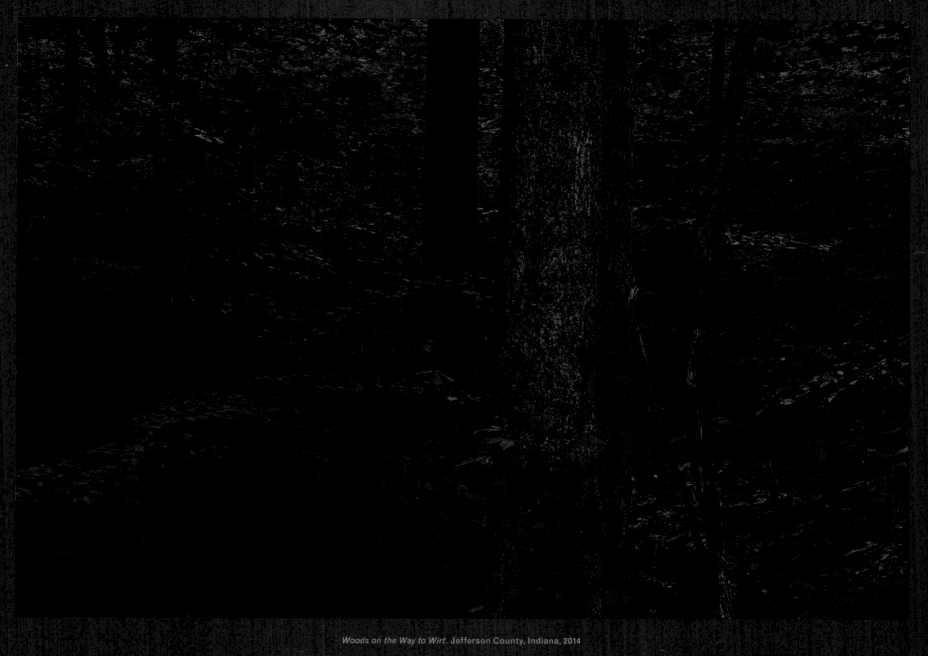

Woods on the Way to Wirt. Jefferson County, Indiana, 2014

Wade in the water,
wade in the water children,
God's a-going to trouble the water

—AFRICAN-AMERICAN SPIRITUAL

Wade in the Water. Graham Creek in Jennings County, Indiana, 2013

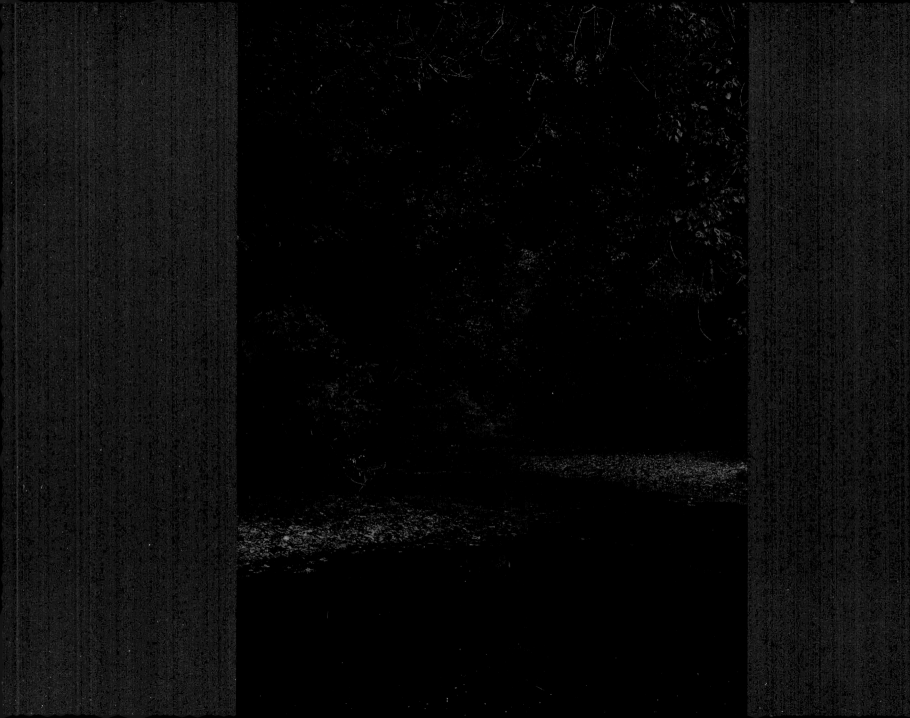

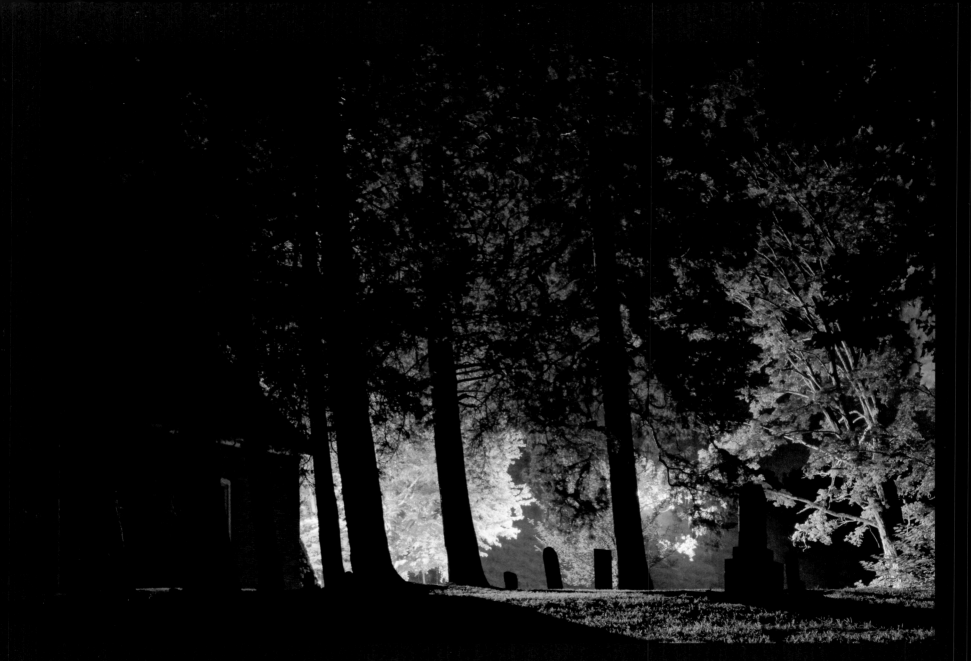

On the Way to the Hicklin House Station. San Jacinto, Indiana, 2013

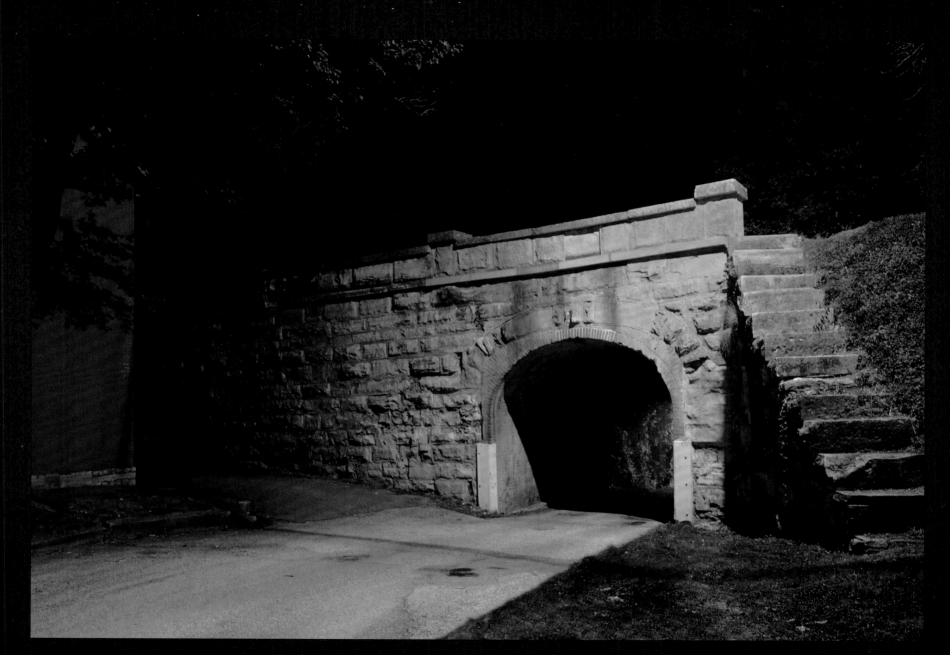

Follow the Tracks to the First Creek. Just outside Richland, a free black community, Stone Arch Railroad Bridge, Vernon, Indiana, 2013

For the old man is a-waiting

for to carry you to freedom.

If you follow the drinking gourd.

—AFRICAN-AMERICAN SPIRITUAL ABOUT THE BIG DIPPER,
WHICH POINTS TO THE NORTH STAR

Follow the Drinking Gourd. Jefferson County, Indiana, 2013

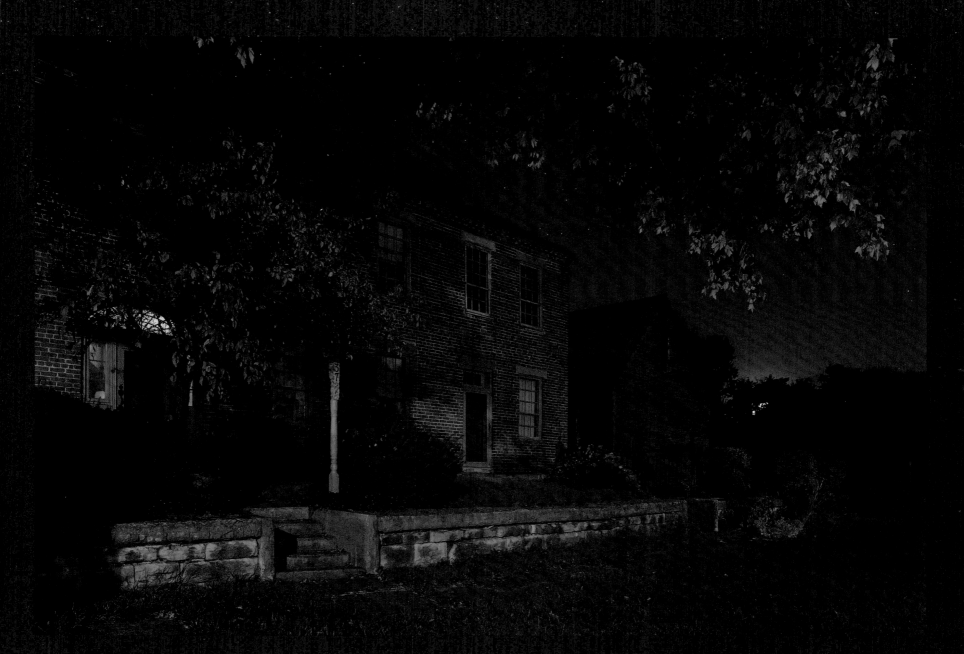

Elias Conwell House. Along Old Michigan Road, a major north-south artery between Kentucky and Michigan, Napoleon, Indiana, 2013

Moonrise Over Northern Ripley County. From the Decatur County line, Indiana, 2013

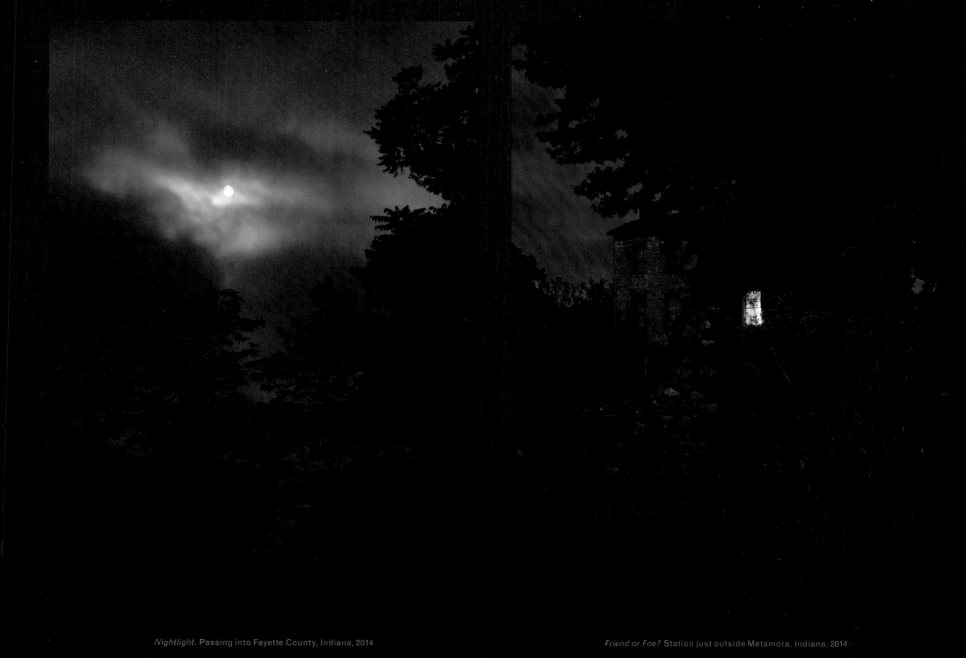

Nightlight. Passing into Fayette County, Indiana, 2014

Friend or Foe? Station just outside Metamora, Indiana, 2014

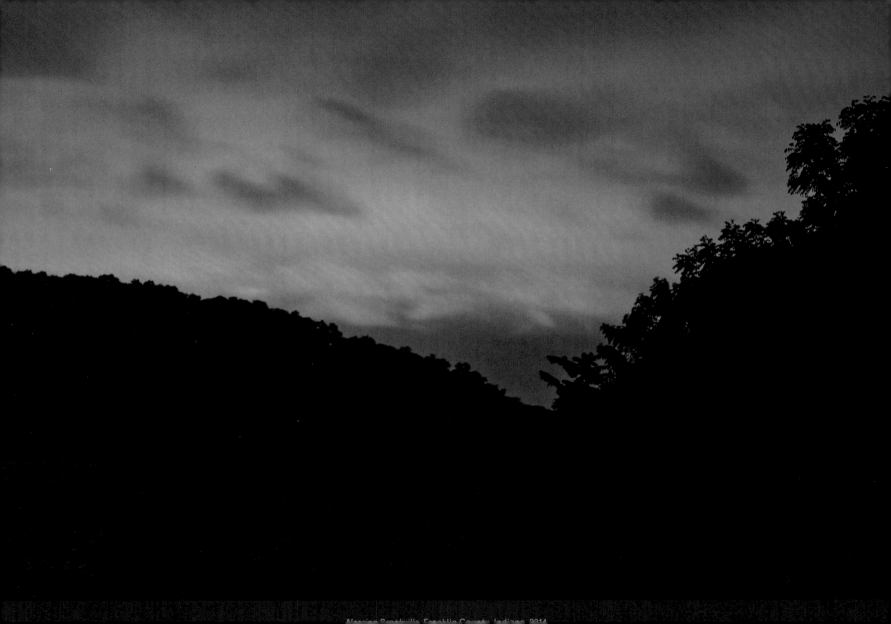

My God helping me,

there shall be a perpetual war

between me and human slavery.

—ADAM LOWRY RANKIN, ABOLITIONIST

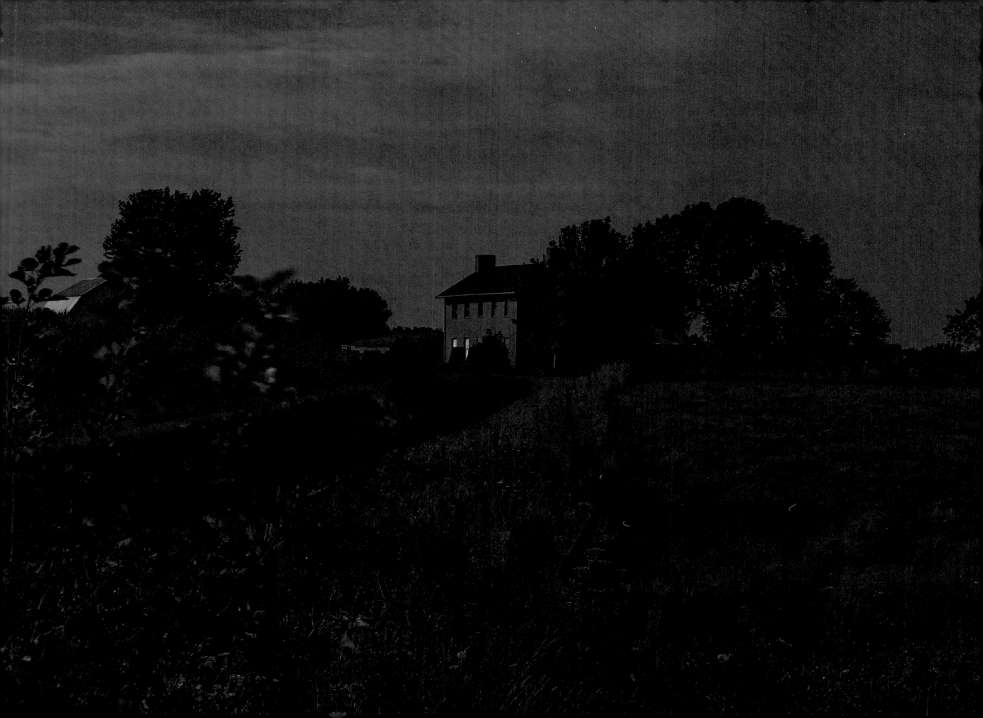

Go to the House on the Hill. Possible Underground Railroad station, Cambridge City, Indiana, 2013

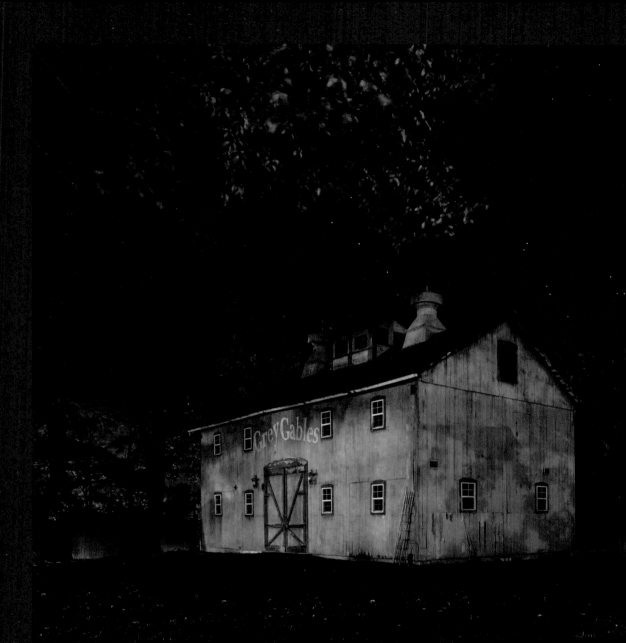

Look for the Gray Barn Out Back. Joshua Eliason Jr. barnyards and farmhouse, with a tunnel leading underneath the road to another station, Centerville, Indiana, 2013

A Very Good Road. Drawing near the Bishop Paul Quinn Station, Richmond, Indiana, 2014

*The dictates of humanity came in opposition
to the law of the land, and we ignored the law.*

—LEVI COFFIN

A Safe Place to Regroup. House of Levi Coffin, who was unofficially dubbed the president of the
Underground Railroad, Fountain City (formerly Newport), Indiana, 2014

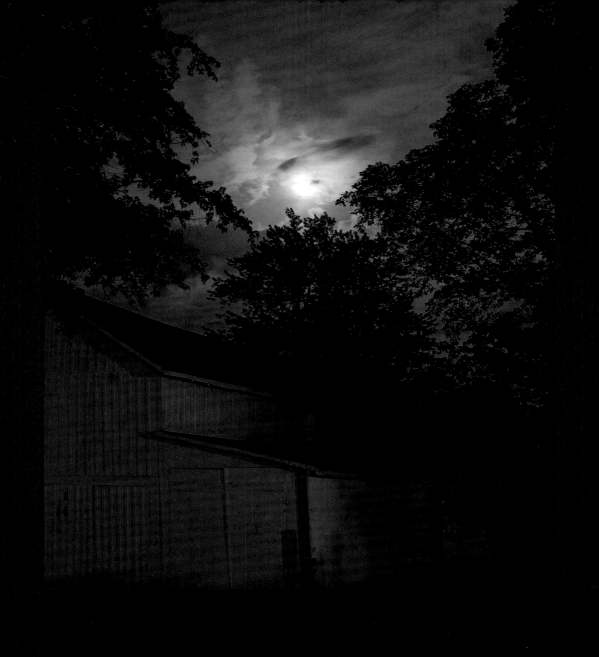

Differences in government, discipline, and privileges
will not be made with regard to color, rank, or wealth.

—ARTICLE 8 OF THE UNION LITERARY INSTITUTE CONSTITUTION

Approaching the Seminary. Near Spartanburg, Indiana, 2014

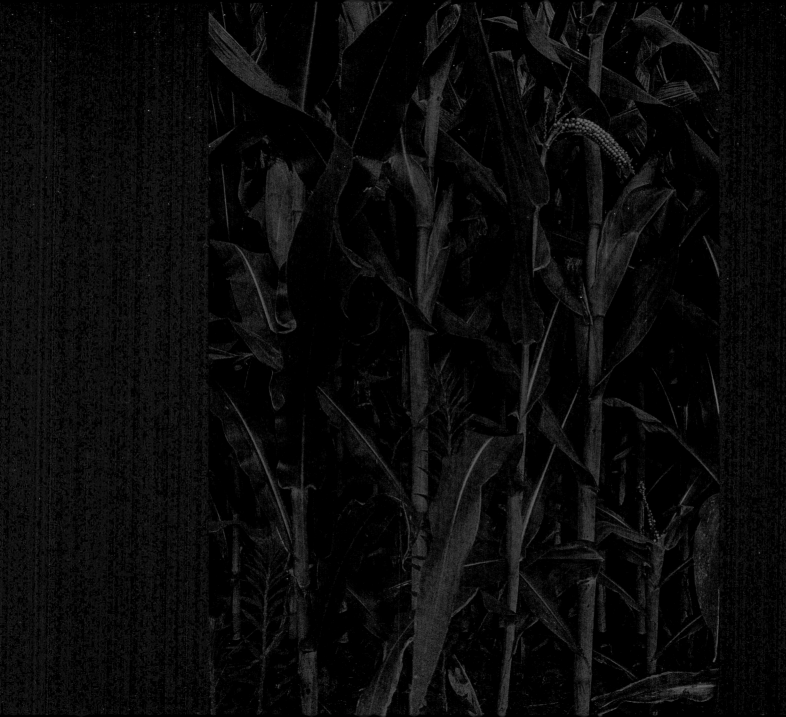

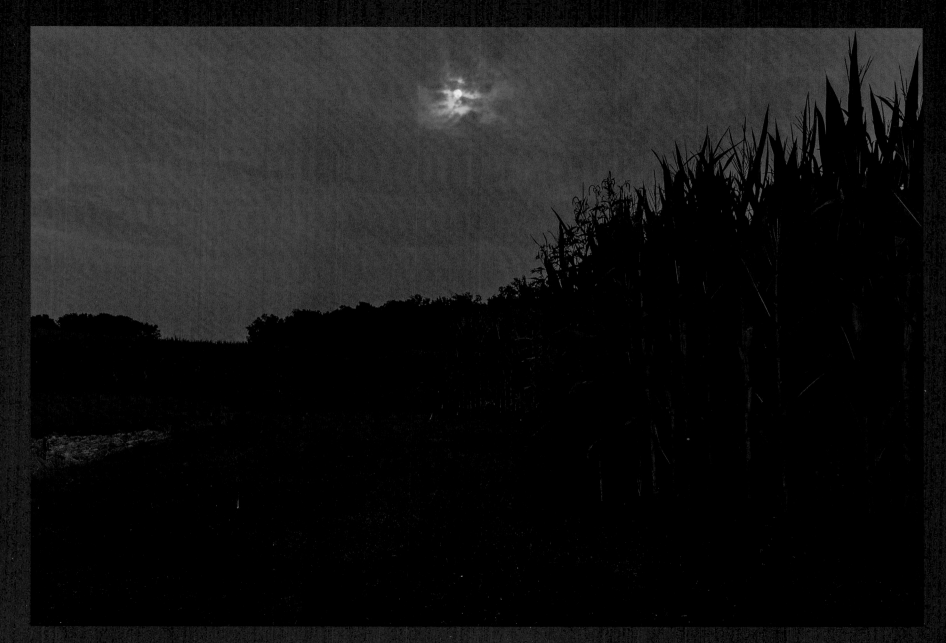

Taking Cover with the Fireflies. North of Winchester, Indiana, 2014

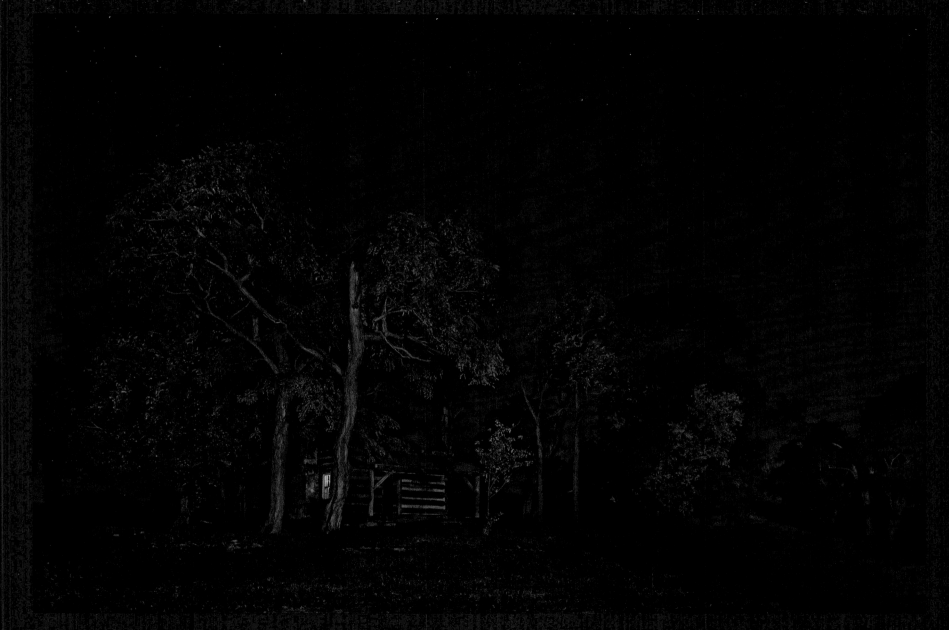

On the Safest Route. James and Rachel Sillivan cabin, Pennville (formerly Camden), Indiana, 2014

Orange Moon. Adams County, Indiana, 2014

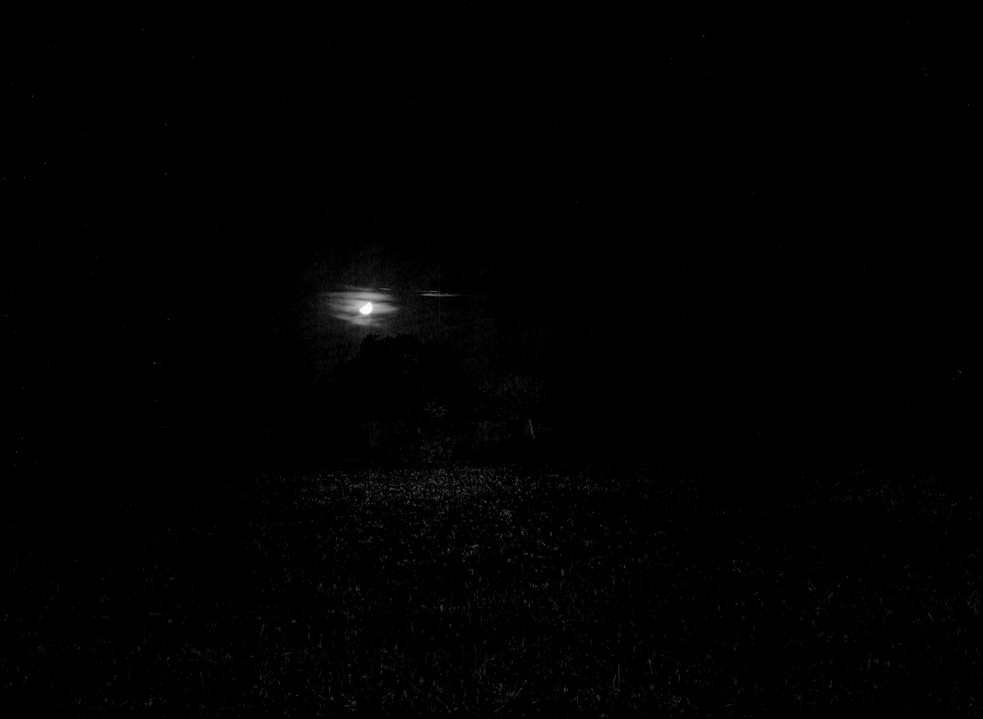

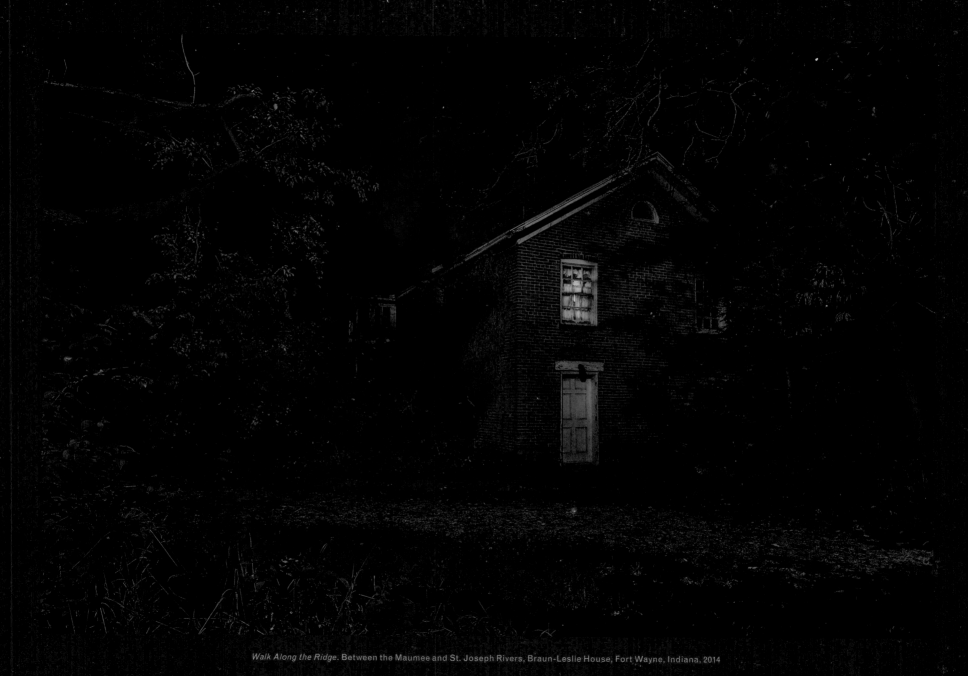

Walk Along the Ridge. Between the Maumee and St. Joseph Rivers, Braun-Leslie House, Fort Wayne, Indiana, 2014

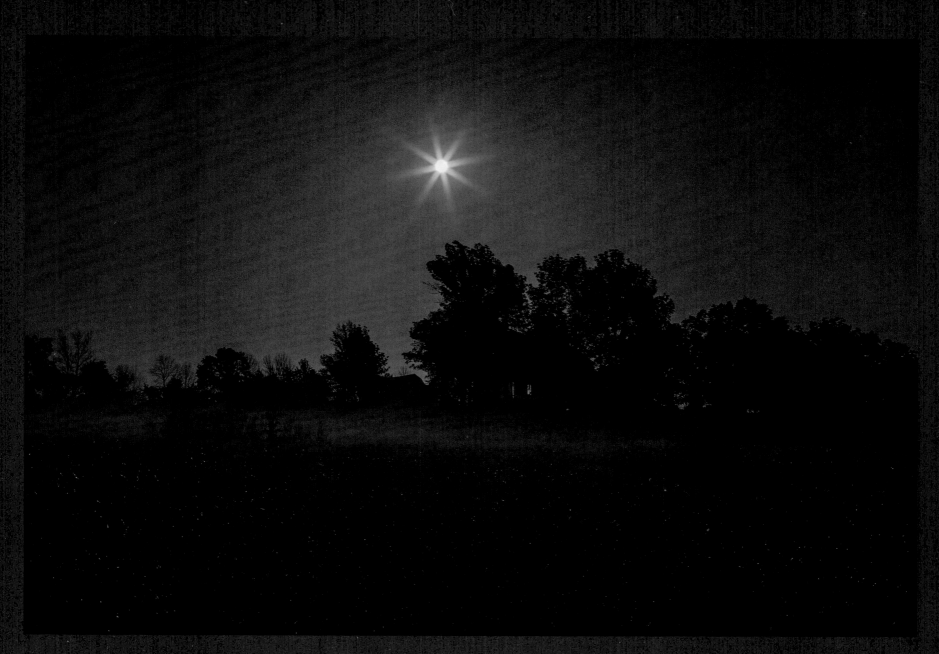

Lying Low. William Cornell House, outside Auburn, Indiana, 2014

Queen Anne's Lace, South Steuben County, Indiana, 2014

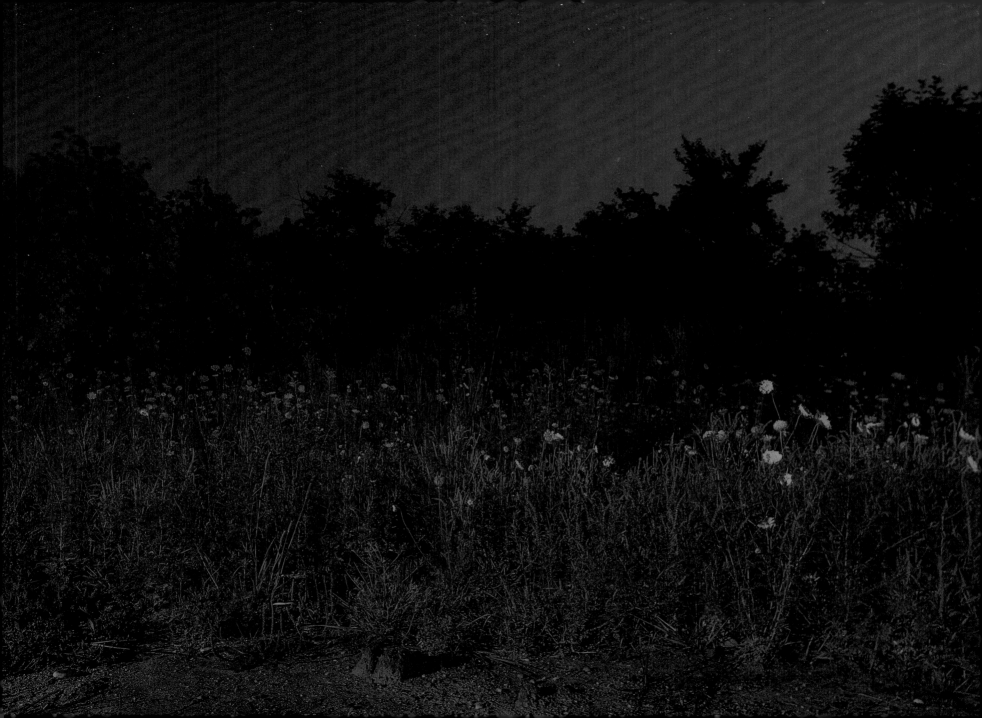

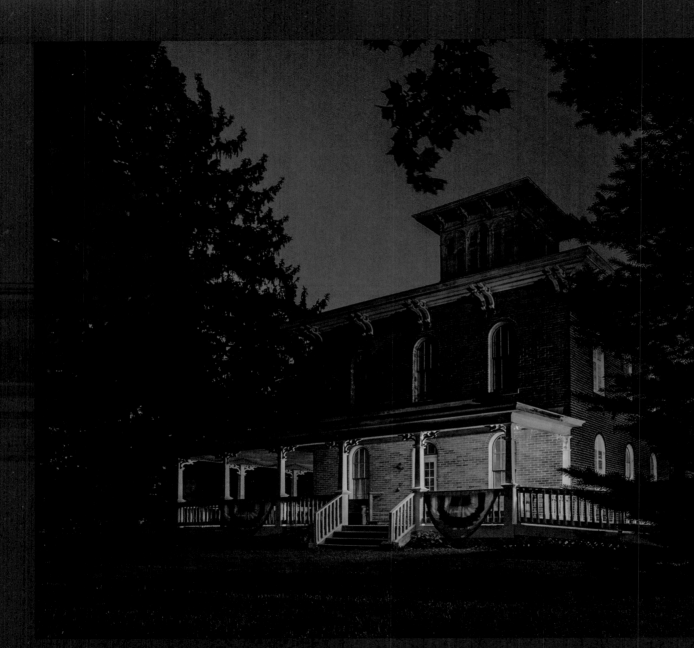

Bird's Eye View. Erastus Farnham House, south of Fremont, Indiana, 2014

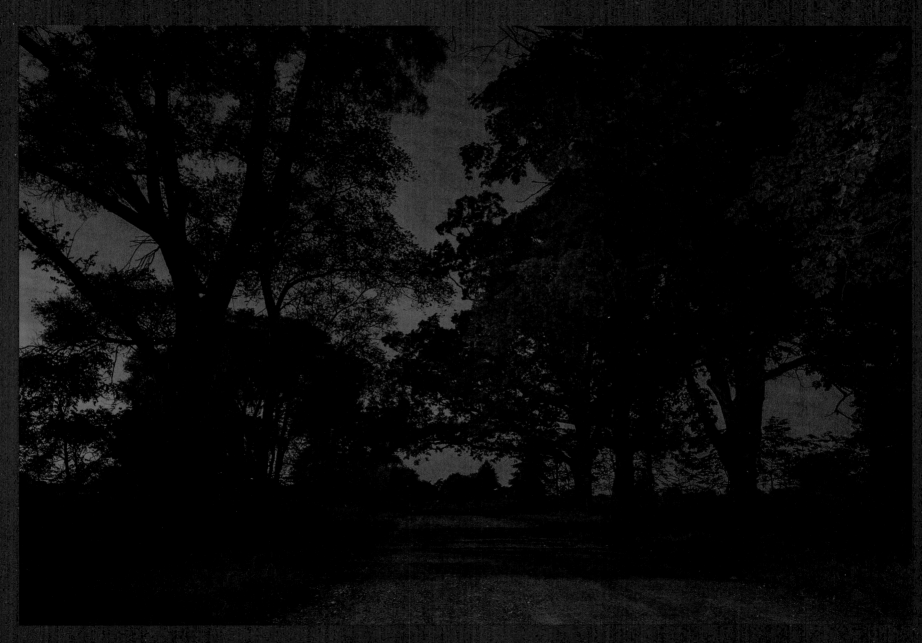

Dirt Road. Outside Coldwater, Michigan, 2014

Concealed in the Fog. Near Jonesville, Michigan, 2014

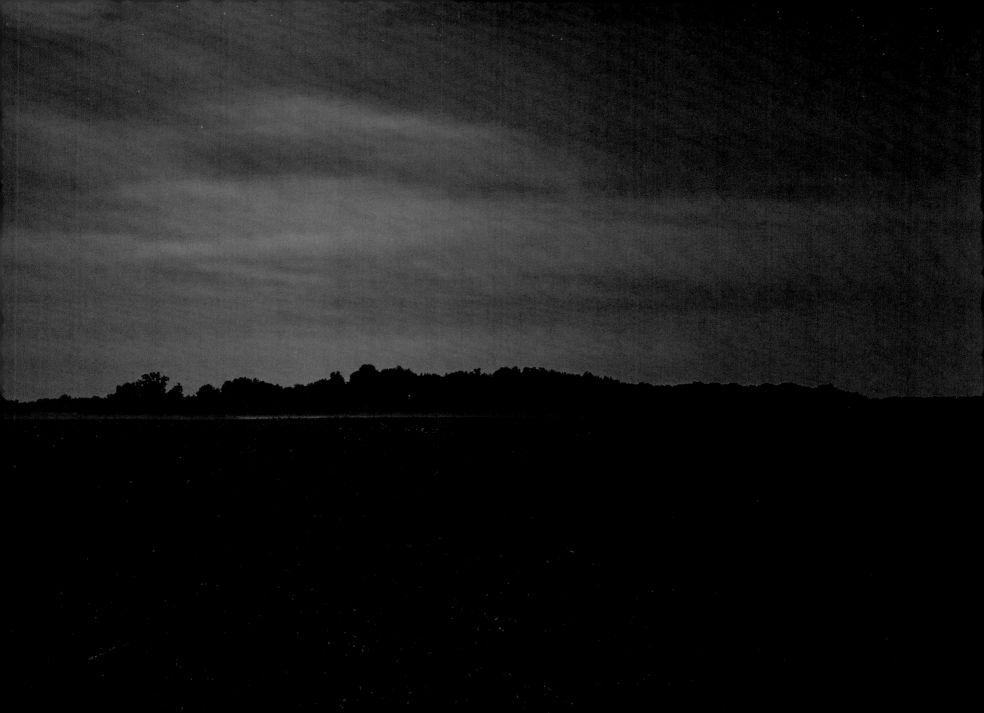

Wright Ray, a noted negro catcher…

was also sheriff of Jefferson County for many years
and used his office for that purpose.
[He] was known all over Kentucky and was always applied to
when a slave got away.

—JOHN H. TIBBETS

Nearing the Farm. Royal Watkins farmstead, Jackson County, Michigan, 2014

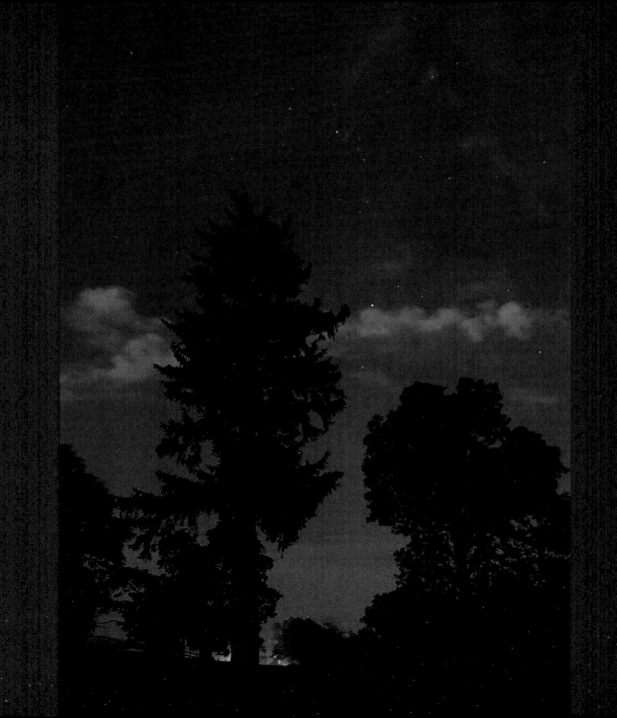

Liberty to the fugitive captive and the oppressed
over all the earth, both male and female of all colors.

—SIGN AT THE GATE TO CAPTAIN JOHN LOWRY'S PROPERTY

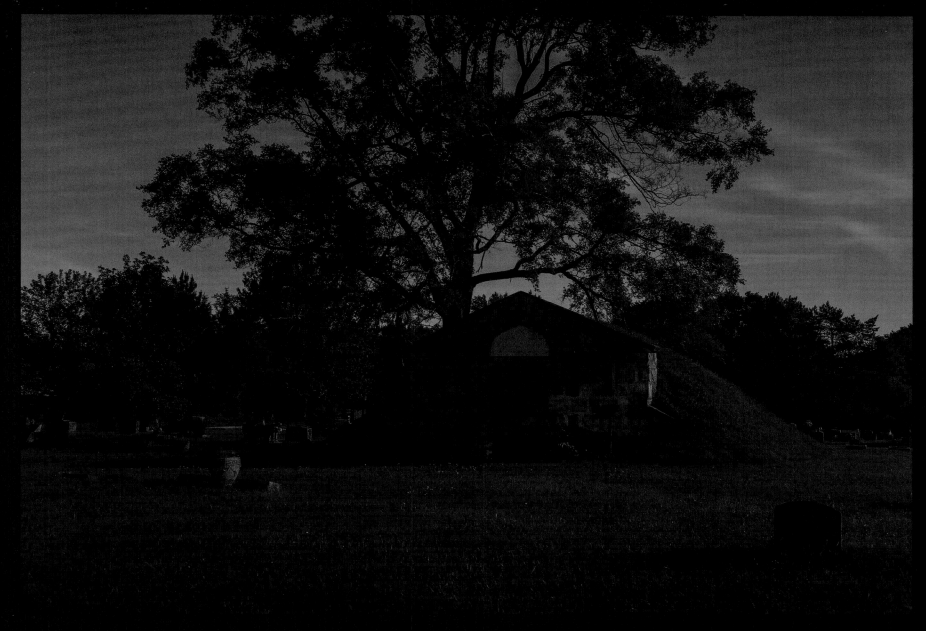

"Liberty to the Fugitive Captive." Waiting for the all-clear to head to the Captain John Lowry Station, Lodi Plains Cemetery, Nutting's Corner, Michigan, 2014

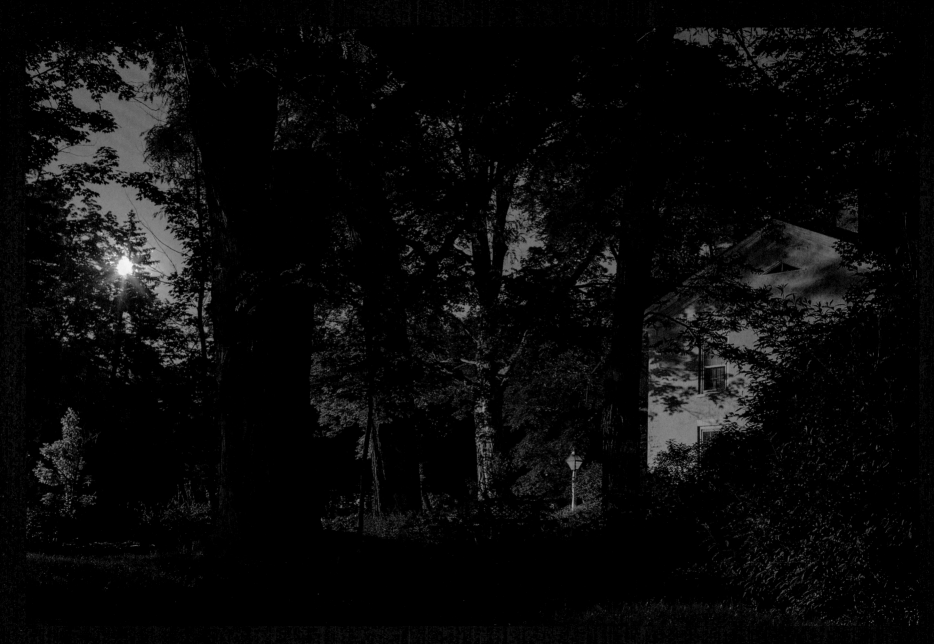

Moon Over the "Old Slave House." Reverend Guy Beckley's home north of the Huron River, Lower Town, Michigan, 2014

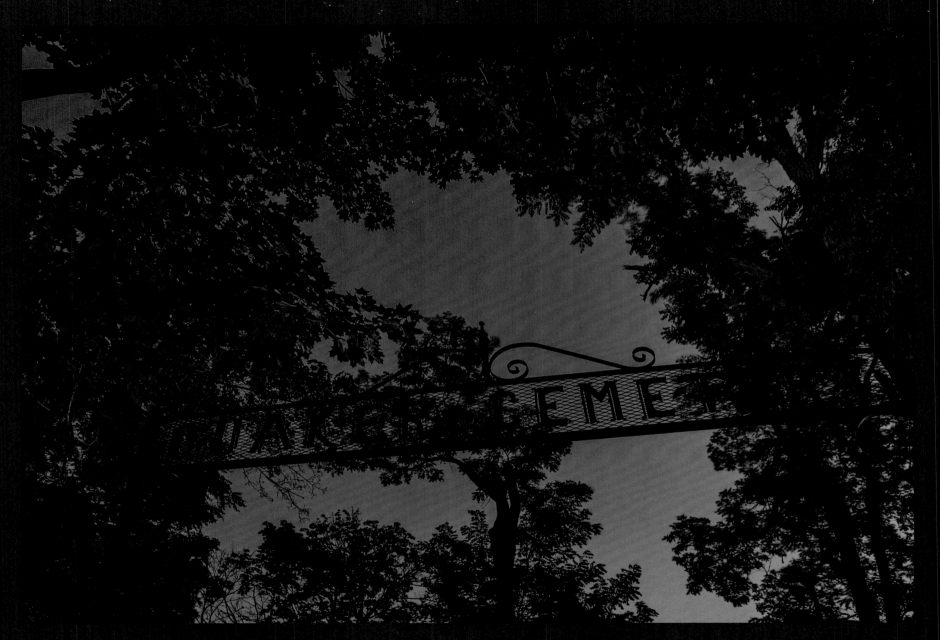

Delayed Arrival. Arthur and Nathan Power Station, Quakertown, Michigan, 2014

Wait for the Call of the Hoot Owl. Oakland County, Michigan, 2014

The Beacon Tree. Spring Hill Farm, Macomb County, Michigan, 2014

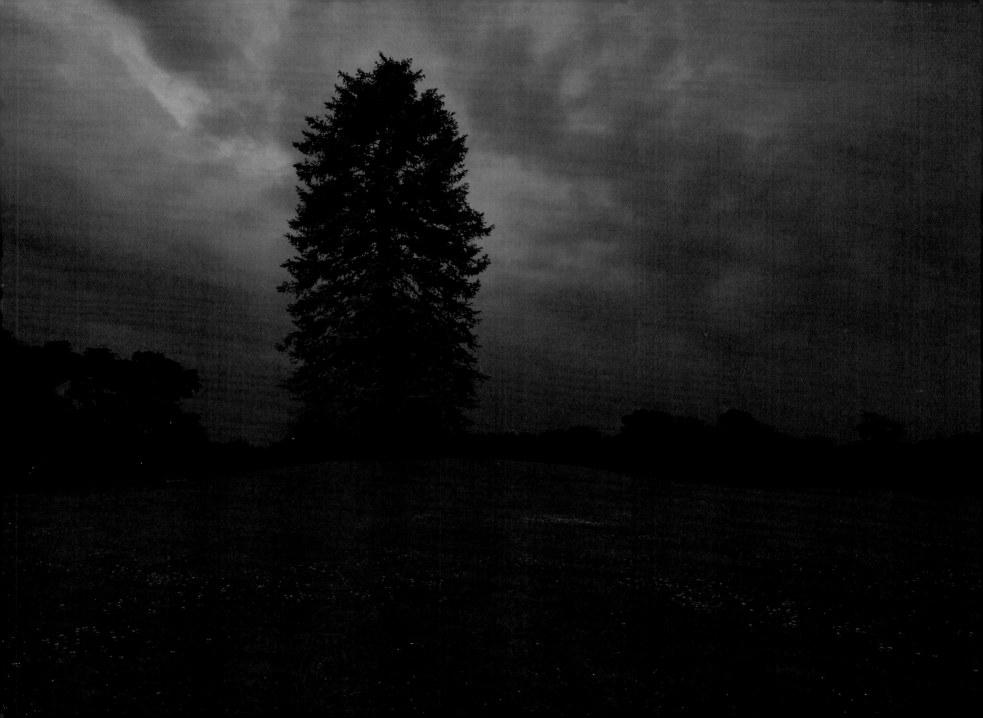

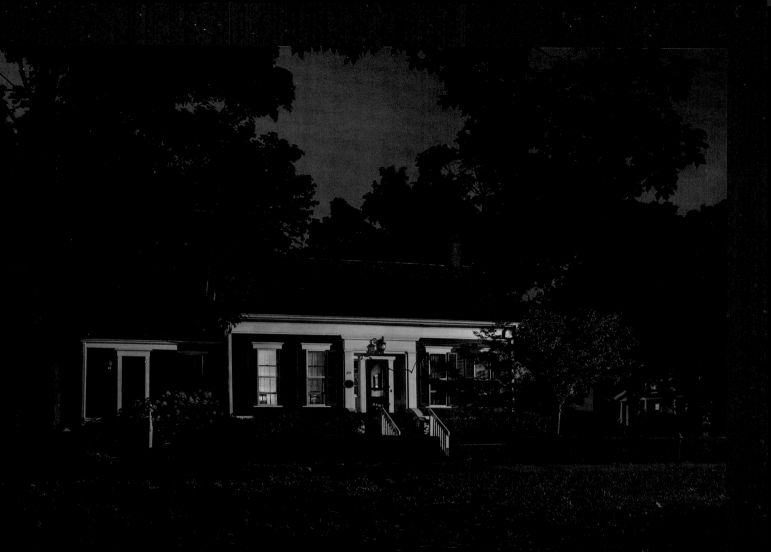

A Place of Rest. Rufus Nutting House, Romeo, Michigan, 2014

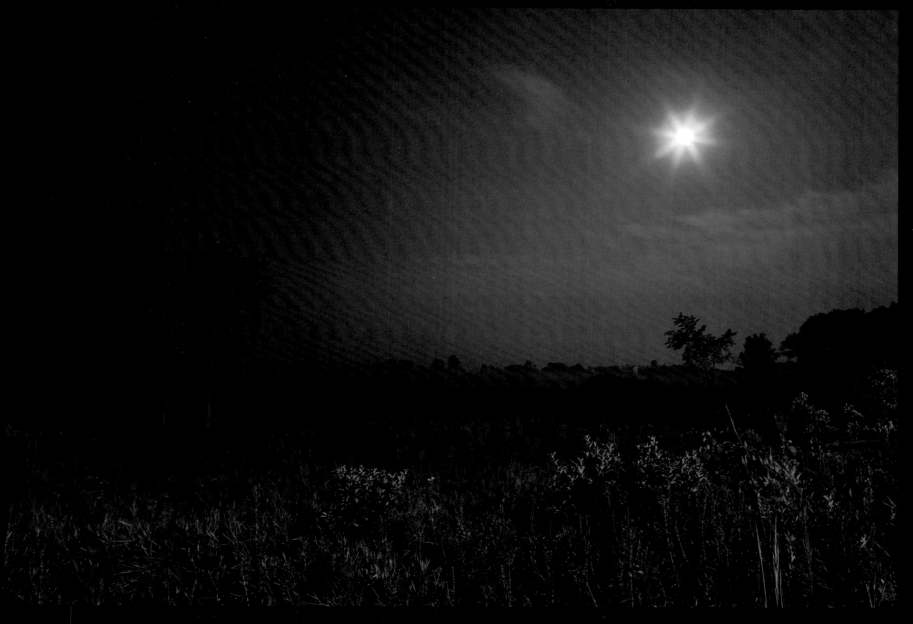

Scrub Field. Leaving Reverend Óren Cook Thompson Station, St. Clair County, Michigan, 2014

Slaves cannot breathe in England [and Canada]: if their lungs

Receive our air, that moment they are free;

They touch our country, and their shackles fall.

—WILLIAM COWPER

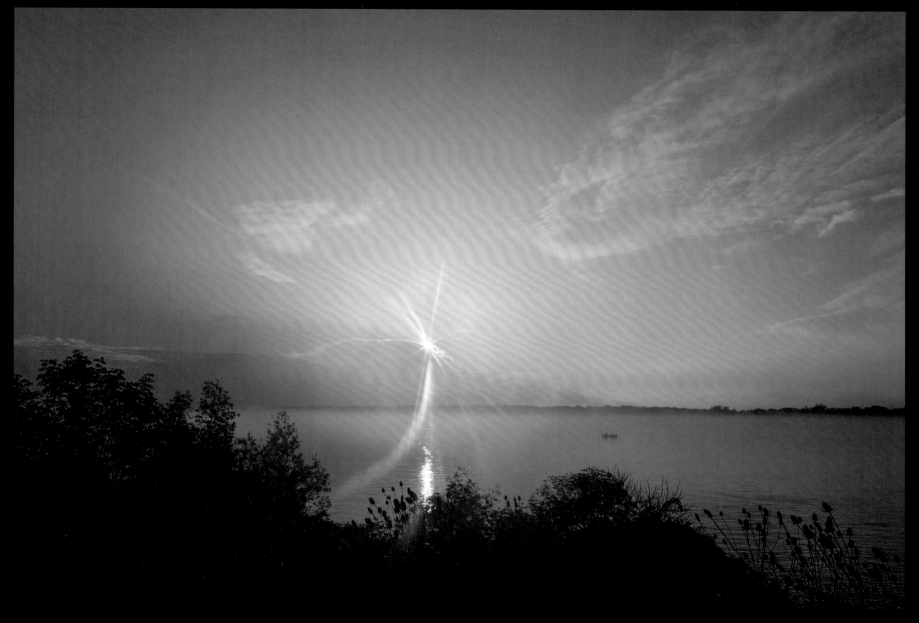

Within Reach. Crossing the St. Clair River to Canada just south of Port Huron, Michigan, 2014

Freedom. Canadian soil, Sarnia, Ontario, 2014

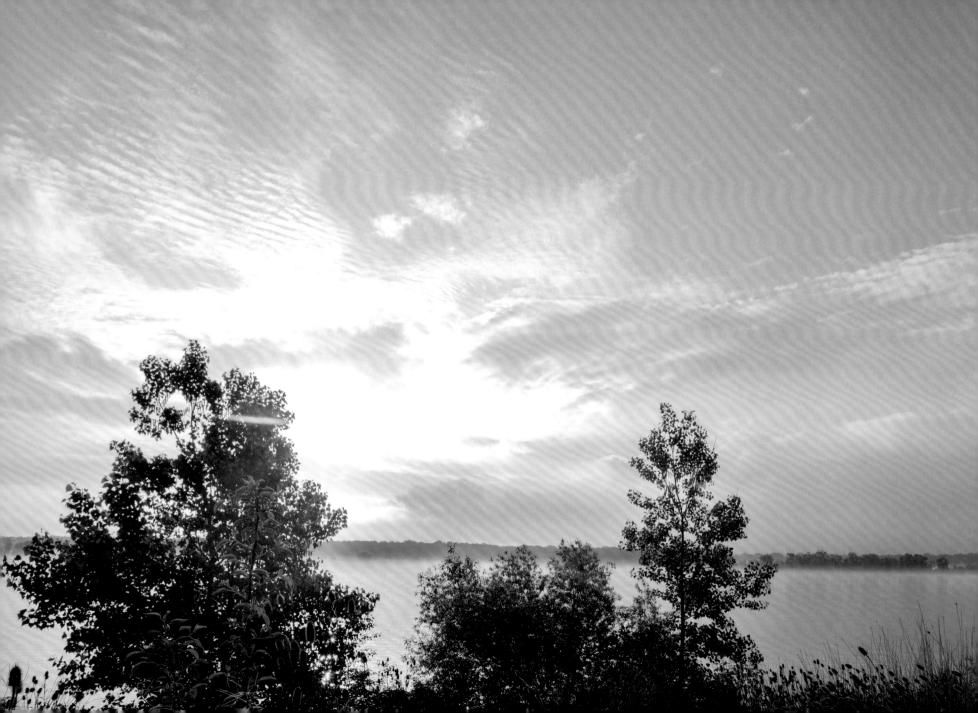

I looked at my hands to see if I was the same person now I was free.
There was such a glory over everything, the sun came
like gold through the trees, and over the fields,
and I felt like I was in heaven.

—HARRIET TUBMAN

Notes on the Photographs

PAGE 99: Josephus Conn Guild, a prominent Tennessee attorney and owner of the Rose Mont Plantation, represented twenty-four slaves who were granted manumission in their master's will, but were denied freedom by the executor of the estate. On January 26, 1846, the Tennessee Supreme Court upheld their right to be free.

PAGE 105: Documents show that "passengers" of the Underground Railroad passed through the cities surrounding Mammoth Cave, including Cave City, Glasgow, and Murfreesboro, where they could safely cross the Green River. While there is no evidence that the cave itself was used by the Underground Railroad, the most accurate map of the cave system was drawn in the 1842 by Stephen Bishop, a slave and a cave guide who gave tours to travelers. The map was published in 1845 by Morton & Griswold Publishers and was still being utilized as the main source of reference for the cave in 1887.

PAGE 116–17: The origin of the term "Underground Railroad" is disputed. Abolitionist Rush Sloane offered an account in 1831, stating that the term originated from an episode in which a fugitive slave, Tice Davids, fled across the Ohio River pursued by his owner. Upon reaching the shore, Davids disappeared, leaving the bewildered slaveholder to wonder if Davids had somehow "gone off on an underground road." (Ohio History Connection. "Tice Davids." http://www.ohiohistorycentral.org/w/Tice_Davids) Another story states that the term came into use among frustrated slave hunters in Pennsylvania, and a third tale, from 1839 in Washington, DC, alleges that a fugitive slave, after being tortured, claimed that he was to have been sent north, where "the railroad ran underground all the way to Boston." (Robert C. Smedley, *History of the Underground Railroad in Chester and the Neighboring Counties of Pennsylvania* [Lancaster, Pennsylvania: 1883] quoted in David W. Blight, *From Passages to Freedom: The Underground Railroad in History and Memory* [Washington, DC: Smithsonian Books in association with the National Underground Railroad Freedom Center, 2004], 3.

PAGE 119: At Eagle Hollow, part of a network of Underground Railroad stations that shepherded slaves northward through Indiana, Chapman Harris—a free man, reverend, and blacksmith—signaled safe crossing to fugitives waiting on the Kentucky shore of the Ohio River with hammer strokes on his anvil.

PAGE 129: Some scholars believe that the signature line in the chorus of "Follow the Drinking Gourd" is not original and attribute it to Lee Hays, who published it eighty years after the end of the Civil War. According to other accounts, however, this chorus was heard as early as the 1840s.

PAGE 139: Members of the Henry County Female Anti-Slavery Society took up donations to buy 127 yards of free-labor cotton in order to sew garments: vests, coats, pants, dresses, shirts, and socks. Two-thirds of the garments were directed to Salem, Union County, care of William Beard.

PAGE 141: The current occupants of the former farmhouse and barn verify the existence of a tunnel connecting the two buildings. It was sealed long ago.

PAGE 145: The Underground Railroad was a loosely organized network whose participants had no titles, but friends and supporters of Levi Coffin—who, with his wife, Catherine, was an important organizer and abolitionist over four decades—referred to him as "president."

PAGE 151: Several documents from the mid-1800s to the present indicate that Eliza Harris stayed at this location during her flight northward. Her crossing of the Ohio River would become one of the best known escapes due to her representation in Harriet Beecher Stowe's 1852 novel *Uncle Tom's Cabin*.

PAGE 167: Sylvia and Captain John Lowry boldly invited freedom seekers to their home via a large board sign that was above the gate to their yard. It was painted with two figures, one white and the other black, holding a scroll between them. Their daughter, Mary E., described the sign: "The figure at the right is a female form, with heavy chain in the left hand, but broken are the links. In her right hand she holds the balances. To the left, and in the act of rising, is the figure of a man of darker hue … but, clad in freeman's garb; while around one wrist is clasped the other end of slavery's chain, with many missing links, and to his sister he looks up for help and perfect freedom, their faces all aglow with triumph, and just below appears this motto: 'liberty to the fugitive captive and the oppressed over all the earth, both male and female of all colors.'" Carol E. Mull, *The Underground Railroad in Michigan* (Jefferson, NC: McFarland & Co., Publishers, 2010), 94.

PAGE 173: A composite of photographs from two different locations, this image represents a memory described by Liberetta, the daughter of Peter and Sarah Lerich. As a five-year-old, Liberetta witnessed her parents and their neighbors John Narramoor, John Waters, and Mr. and Mrs. Fuller uprooting a massive cedar and pulling the tree—with three yoke of oxen—to the top of a hill, where they replanted it. Gathering near the tree, the group prayed for their "black brethren" and the "down-trodden race" and sprinkled newspaper clippings of the *National Era* on the cedar's roots. Mrs. Narramoor soon arrived, announcing that the tree was visible a mile away.

Epigraph Sources

PAGE 32: Frederick Douglass, *Narrative of the Life of Frederick Douglass* (New York: Dover Publications, 1995), 9.

PAGE 41: Frederick Douglass and David W. Blight, *My Bondage and My Freedom* (New Haven, CT: Yale University Press, 2014), 226.

PAGE 42: Eber M. Pettit, *Sketches in the History of the Underground Railroad* (Westfield, NY: Chautauqua Region Press, 1999), 31.

PAGE 44: "Run, Mary, Run" in James Weldon Johnson, J. Rosamond Johnson, and Lawrence Brown, *The Books of American Negro Spirituals* (New York: Da Capo Press, 2003), 110.

PAGE 52: Federal Writers' Project, *Tennessee Slave Narratives: A Folk History of Slavery in Tennessee from Interviews with Former Slaves* (Washington, DC: Library of Congress, 2006), cover.

PAGE 58: Douglass, *My Bondage and My Freedom*, 41.

PAGE 66: Jacob Cummings, "Interview with Reverend Jacob Cummings, an Escaped Slave Living in Columbus, Ohio" in *The Underground Railroad in Indiana*, vol. 1, ed. Wilbur H. Siebert, Wilbur H. Siebert Collection, Ohio Historical Society.

PAGE 72: Pettit, *Sketches in the History of the Underground Railroad*, 128.

PAGE 76: David W. Blight, *A Slave No More: Two Men Who Escaped to Freedom: Including Their Own Narratives of Emancipation* (Boston: Mariner Books, 2007), 243.

PAGE 86: Frederick Douglass, *The Life and Times of Frederick Douglass* (Mineola, NY: Dover Publications, 2003), 109.

PAGE 88: Pettit, *Sketches in the History of the Underground Railroad*, 118.

PAGE 94: Pettit, *Sketches in the History of the Underground Railroad*, 96.

PAGE 100: Pettit, *Sketches in the History of the Underground Railroad*, 114.

PAGE 102: Sarah Bradford, *Harriet, the Moses of Her People* (Chapel Hill: University of North Carolina Press, 2012), 17–18.

PAGE 122: John H. Tibbets, *Reminiscences of Slavery Times*, unpublished chronicle, 1888, collection of Eluetherian College, Inc., Lancaster, Indiana.

PAGE 138: Fergus Bordewich, *Bound for Canaan: The Epic Story of the Underground Railroad, America's First Civil Rights Movement* (New York: Amistad, 2006), 126.

PAGE 144: Bordewich, *Bound for Canaan*, 64.

PAGE 146: Union Literary Institute Minutes Book, 1845–1890, Indiana Historical Society, BV1972, 18.

PAGE 164: Tibbets, *Reminiscences of Slavery Times*.

PAGE 166: Carol E. Mull, *The Underground Railroad in Michigan* (Jefferson, NC: McFarland & Co., Publishers, 2010), 94.

PAGE 178: William Craft, *Running a Thousand Miles for Freedom; or, The Escape of William and Ellen Craft from Slavery* (London: Aeterna Publishing, 2010), i.

PAGE 183: National Park Service, US Department of the Interior, *Underground Railroad* (Washington, DC: US Government Printing Office, 2005), 44.

Bibliography

Allen, William Francis, Charles Pickard Ware, and Lucy McKim Garrison, eds. *Slave Songs of the United States*. New York: A. Simpson & Co., 1867.

Beck, Isaac, interview with Wilbur H. Siebert, December 26, 1892. Wilbur H. Siebert Collection, Ohio Historical Society, Columbus.

Bentley Historical Library, Ann Arbor, Michigan, Lorenzo Davis papers, 1822–1899.

Blight, David W. *A Slave No More: Two Men Who Escaped to Freedom: Including Their Own Narratives of Emancipation*. Boston: Mariner Books, 2007.

———. *From Passages to Freedom: The Underground Railroad in History and Memory*. Washington, DC: Smithsonian Books in association with the National Underground Railroad Freedom Center, 2004.

Bordewich, Fergus M. *Bound for Canaan: The Epic Story of the Underground Railroad, America's First Civil Rights Movement*. New York: Amistad, 2006.

Bradford, Sarah. *Harriet, the Moses of Her People*. Chapel Hill: University of North Carolina Press, 2012.

Bresler, Joel. "Follow the Drinking Gourd: A Cultural History." http://www.followthedrinkinggourd.org/.

Burton Historical Collection, Detroit Public Library.

Childe, Lydia Maria. *Isaac T. Hopper: A True Life*. Boston: John P. Jewett & Co., 1853.

Clifford Larson, Kate. *Bound for the Promised Land: Harriet Tubman, Portrait of an American Hero*. New York: Random House, 2003.

Coffin, Levi. *Reminiscences of Levi Coffin*. Edited by Ben Richmond. Philadelphia: Friends United Press, 2001.

Cole, Andrea. "Underground Railroad: Researchers Uncover County's Role in Slaves' Journey to Freedom." *Palladium-Item*, Richmond, Indiana.

Cone, James H. *The Spirituals and the Blues: An Interpretation*. New York: Seabury Press, 1971.

Coon, Diane Perrine. "Kentucky-Indiana Underground Railroad Crossings at Carroll and Trimble Counties." *The Madison Connection*, Jefferson County Historical Society Research Library.

———. "Reconstructing the Underground Railroad Crossings at Madison, Indiana." Masters thesis, University of Louisville, 1998. Jefferson County Historical Society Research Library.

Craft, William. *Running a Thousand Miles for Freedom; or, The Escape of William and Ellen Craft from Slavery*. London: Aeterna Publishing, 2010.

Darden, Robert. *People Get Ready!: A New History of Black Gospel Music*. New York: Bloomsbury, 2013.

Dobie, J. Frank, ed. *Follow de Drinkin' Gou'd*. Austin: Texas Folk-Lore Society, 1928.

———. *Nothing But Love in God's Water, Volume I: Black Sacred Music from the Civil War to the Civil Rights Movement*. University Park: Pennsylvania State University Press, 2014.

Douglass, Frederick. "American Slavery, American Religion, and the Free Church of Scotland: An Address Delivered in London, England, on May 22, 1846." In *The Frederick Douglass Papers: Series One—Speeches, Debates, and Interviews*. Edited by John Blassingame et al. New Haven, CT: Yale University Press, 1979.

———. *Autobiographies*. New York: The Library of America, 1994.

———. *The Life and Times of Frederick Douglass*. Mineola, NY: Dover Publications, 2003. First published 1892 by De Wolfe & Fiske.

———. *Narrative of the Life of Frederick Douglass*. New York: Dover Publications, 1995. First published as *Narrative of the Life of Frederick Douglass, an American Slave*. Boston: Anti-Slavery Office, 1845.

Douglass, Frederick, and David W. Blight. *My Bondage and My Freedom*. New Haven, CT: Yale University Press, 2014.

Drew, Benjamin. *The Refugee: Narratives of Fugitive Slaves in Canada*. Toronto, Dundurn Press, 2008.

Epstein, Dena J. *Sinful Tunes and Spirituals: Black Folk Music to the Civil War.* Urbana: University of Illinois Press, 1977.

Federal Writers' Project. *Tennessee Slave Narratives: A Folk History of Slavery in Tennessee from Interviews with Former Slaves.* Bedford, MA: Applewood Books; Washington, DC: Library of Congress, 2006.

Feeder, Luther M. "Our History Scrapbook: Lacey Among 5 Slavery Foes in Fountain City Picture in 1922." *The Palladium-Item and Sun-Telegram*, Richmond, Indiana, February 6, 1962.

Franklin, John Hope, and Alfred A. Moss Jr. *From Slavery to Freedom: A History of African Americans.* New York: Knopf, 1967.

Franklin, John Hope, and Loren Schweninger. *Runaway Slaves: Rebels on the Plantation.* New York: Oxford University Press, 1999.

Free Labor Advocate and Anti-Slavery Chronicle, New Garden, Indiana, 1841–1847.

Funk, Arville L. "Railroad to Freedom." *Outdoor Indiana* (November 1964): 5–9.

Gara, Larry. *The Liberty Line: The Legend of the Underground Railroad.* Lexington: University of Kentucky Press, 1961.

Genovese, Eugene D. *Roll, Jordan, Roll: The World the Slaves Made.* New York: Pantheon Books, 1974.

Gilbert, Olive, and Sojourner Truth. *Narrative of Sojourner Truth.* Mineola, NY: Dover Publications, 1997.

Greensburg Daily News, Greensburg, Indiana, 1894.

Henry County (Indiana) Female Anti-Slavery Society records, Rare Books and Manuscripts Department, Indiana State Library.

Hewitt, Nancy A. *Women's Activism and Social Change: Rochester, New York 1822–1872.* Ithaca, NY: Cornell University Press, 1984.

Higginson, Col. Thomas W. *Army Life in a Black Regiment.* 2nd ed. Edited by Eileen Southern. New York: W. W. Norton & Company, 1883.

Jeffrey, Julie Roy. *The Great Silent Army of Abolitionism: Ordinary Women in theAntislavery Movement.* Chapel Hill: University of North Carolina Press, 1998.

Johnson, James Weldon, ed., and J. Rosamund Johnson, musical arranger. *The Book of American Negro Spirituals.* New York: Viking Press, 1925.

Johnson, James Weldon, J. Rosamond Johnson, and Lawrence Brown. *The Books of American Negro Spirituals.* New York: Da Capo Press, 2003.

Liberator, Boston, Massachusetts, 1831–1865.

Library of Congress. *The Frederick Douglass Papers at the Library of Congress.* Washington, DC: Manuscripts Division, Library of Congress, 2001. http://memory.loc.gov/ammem/doughtml/.

Lovell, John, Jr. *Black Song: The Forge and the Flame. The Story of How the Afro American Spiritual Was Hammered Out.* New York: Paragon House Publishers, 1972.

Marsh, J. B. T. *The Story of the Jubilee Singers: With Their Songs.* New York: AMS Press, 1971.

Mihacka, Fauna. *Anti-Slavery History of Jefferson County*, paper, 1998. Jefferson County Historical Society Research Library.

Mull, Carol E. *The Underground Railroad in Michigan.* Jefferson, NC: McFarland & Co., Publishers, 2010.

National Park Service, US Department of the Interior. *Underground Railroad.* Washington, DC: US Government Printing Office, 2005.

Ohio History Connection. "Tice Davids." http://www.ohiohistorycentral.org/w/Tice_Davids.

Parker, John P. *His Promised Land: The Autobiography of John P. Parker, Former Slave and Conductor on the Underground Railroad.* Edited by Stuart Seely Sprague. New York: W. W. Norton & Company, 1996.

Pettit, Eber M. *Sketches in the History of the Underground Railroad.* 1879. Reprint, Westfield, NY: Chautauqua Region Press, 1999.

Pennsylvania Gazette, May 23, 1787.

Reuben, Sidney, Eliza, and others vs. Joel Parrish, executor. Middle Tennessee Supreme Court Records, 1846, Box MT78, Tennessee State Library and Archives.

Siebert, Wilbur H. *The Underground Railroad from Slavery to Freedom*. 1898. Reprint, New York: Arno Press, 1968.

Smith, Jay P. "Many Michigan Cities on Underground Railroad in Days of Civil War." *Detroit News*, April 14, 1918.

Still, William. *The Underground Railroad*. Chicago: Johnson Publishing Company, 1970.

Tibbets, John H. *Reminiscences of Slavery Times*. Unpublished chronicle, 1888. Collection of Eluetherian College, Inc., Lancaster, Indiana.

Union Literary Institute Minutes Book, 1845–1890. Indiana Historical Society, BV1972.

Work, John W. *American Negro Songs and Spirituals*. New York: Bonanza Books, 1940.

Contributors

Fergus M. Bordewich is a historian and the author of seven books on American history, including *Bound for Canaan: The Underground Railroad and the War for the Soul of America* (Amistad/Harper Collins, 2005), *America's Great Debate: Henry Clay, Stephen A. Douglas, and the Compromise That Preserved the Union* (Simon & Schuster, 2012), *Washington: The Making of the American Capital* (Amistad/Harper Collins, 2009), and *The First Congress: How James Madison, George Washington, and a Group of Extraordinary Men Invented the Government* (Simon & Schuster, 2016).

Robert F. Darden is a professor of journalism, public relations, and new media at Baylor University. He is the author of *People Get Ready! A New History of Black Gospel Music* (Continuum/Bloomsbury, 2005) and *Nothing But Love in God's Water: Black Sacred Music from the Civil War to the Civil Rights Movement, Volume I* (Penn State University Press, 2014). He is also the cofounder of the Black Gospel Music Restoration Project at Baylor.

Eric R. Jackson is an associate professor of history and director of the Black Studies Department at Northern Kentucky University. He is the coauthor of several books, including *Reflections of African-American Peace Leaders: A Documentary History, 1898–1967* (Edwin Mellen Press, 2003) and *Cincinnati's Underground Railroad* (Arcadia, 2014).

Andrew J. Young is a politician, diplomat, author, activist, and pastor. He has served as a United States congressman, an ambassador to the United Nations, and mayor of Atlanta. As a member of the Southern Christian Leadership Conference (SCLC), Young was a key strategist and negotiator during the campaigns in Birmingham and Selma that resulted in the passage of the Civil Rights Act of 1964 and the Voting Rights Act of 1965. Today, Young is the head of the Andrew J. Young Foundation.

Acknowledgments

Thank you to the librarians, researchers, historians, and academics who helped me track down the sites and resources in this book. Thanks especially to the folks at the Indiana Historical Society, the Indiana State Library, the Indiana Historical Bureau, the Detroit Public Library, the Schomburg Center for Research in Black Culture, and the New Orleans Public Library, and to Thomas Hamm at the Friends Collection at Earlham College, Dustin Fuqua at the Cane River Creole National Historical Park, and Vickie Carson at Mammoth Cave National Park.

I am grateful to Mary Virginia Swanson for believing in the series from the very beginning, and to Jennifer Lippert, Kevin Lippert, Robert Morton, Sara Bader, Elise McHugh, Rob Shaeffer, and Jenny Florence for seeing the potential the series had to become a book and for their guidance in shaping the project.

For their invaluable advice and support on my journey to become an artist, my heartfelt thanks go to Alyssa Coppelman, Malcolm Daniel, Arnika Dawkins, Alexa Dilworth, Kathy Dowell, Roy Flukinger, Tom Gitterman, Megan Hancock, Arpad Kovacs, Russell Lord, Laura Pressley, Tim Wride, and many others. To the amazing team at the Open Society Foundations that put together *Moving Walls 23: Journeys*, including Siobhan Riordan, Yokiko Yamagata, Amy Yenkin, Stuart Alexander, and Susan Meiselas, thank you for creating such a wonderful exhibition. And to others who have chosen to show the series: Yaelle Amir, Lauren Araiza, Arnika Dawkins, Jamie DeSimone, Rupert Jenkins, Karen Haas, Megan Hancock, and Steffi Schulze. I am also most grateful to my fellow Coyotes for their continued friendship, inspiration, and support.

To the serendipity and synchronicity I experienced along the way, from meeting people who could provide much-needed information unexpectedly in the middle of the night, and having cardinals follow me from location to location, to having a hotel TV spontaneously turn on twice so I would wake up and photograph some of the best images in the series. I appreciate this guidance from the Universe.

To Lois Lankford, Rich Lankford, Nicole Michna, Douglas Bales, Tamara Reynolds, Spencer McAllister, Kandie Sue Bales, and others for escorting me during many

late nights and early mornings. To Reverend Greg T. Bailey, JD, Patra Marsden, and Reverend Reginald Wilborn for facilitating my interview with Ambassador Young.

To the volunteers who spend tireless hours putting together portfolio reviews like FotoFest, PhotoNOLA, and Review Santa Fe, I thank you. This project would not be where it is without the support it received from the people I met at the reviews.

For their consistent attention to detail, I want to thank Phil Ober and Tony Rios. Many thanks also to Dan Stanley and the guys at Competitive Cameras for their suggestions about software and equipment.

And for the friends and family who have shown amazing support for the project: there are too many to be named, but you know who you are. My life is so much richer with all of you in it.

To my husband, Mike Bales, my son, Nate Bales, and my German puppy love, Kandie Sue Bales, for their love and support as the project led to many days of travel and filled hours, nights, and weekends over the past three and a half years.

And not least of all, my utmost gratitude to Andrew J. Young and the Andrew J. Young Foundation, Fergus Bordewich, Robert Darden, and Eric Jackson for adding compelling original essays to support the images of an extraordinary journey. I cannot thank you enough for adding your voices to this project.